W9-DJN-423

The Catholic
Theological Union
LIBRARY
Chicago, Ill.

ICONS
THEOLOGY IN COLOR

EUGENE N. TRUBETSKOI

WITHDRAWN

ICONS:
THEOLOGY IN COLOR

Translated from the Russian
by
GERTRUDE VAKAR

With an Introduction
by
PROFESSOR GEORGE M. A. HANFMANN
Harvard University

The Catholic
Theological Union
LIBRARY
Chicago, Ill.

ST. VLADIMIR'S SEMINARY PRESS
1973

ISBN 0-913836-09-5

©Copyright 1973
St. Vladimir's Seminary Press

PRINTED IN THE UNITED STATES OF AMERICA

Table of Contents

— Illustrated Section —

Editor's Preface

The three eloquent essays on the Russian icon by Prince Evgenii Nikolaevich Trubetskoi (1863-1920) treat of matters which are of importance not only to the student of Russian culture and of Eastern Orthodox theology but also to students of history of art. These studies are a remarkable attempt to explain the Russian icon as reflection of a comprehensive religious experience and world view. Steeped in teachings of the Russian church, well versed through personal research in the history of the ancient and medieval world and creatively engaged with Western European philosophy, E. N. Trubetskoi had also mastered that stylistic approach to art which was just emerging at the end of the nineteenth and the beginning of the twentieth century. It is the use of this analysis of artistic forms in the service of religious-philosophical approach which gives Trubetskoi's essays a methodical value for the study of art which goes beyond his immediate fascinating subject of Russian ecclesiastic architecture and painting. In seeking to explore the creation in design and color of visual equivalents for religious emotions and beliefs Trubetskoi was a pioneer, whose work on the icons in some respects has not been surpassed to this day and whose systematic, religiously-founded approach to religious art remains a challenge to modern scholarship.

The time when Trubetskoi wrote was the time when

the Russian icon was rediscovered as a work of art. Trubetskoi himself describes how he witnessed one of the first successful, though by modern standards primitive attempts to clean icons revealing for the first time the glory of their true colors. It was natural that his enthusiasm for discovering Russian religious experience in the Russian icon should have led him to minimalize the role of Byzantine art in the genesis and development of the Russian icons. The modern student must be aware of the complex picture of "the blossoming of church art in different orthodox countries, in Greece, Balkans, Georgia, Russia and elsewhere" (L. Ouspensky) in the thirteenth and fourteenth century arrived at by art historical research of the last three generations. It is the approach, not the art historical framework of Trubetskoi which commands our attention.

A second major theme of Trubetskoi has resurged as a strong concern of our times. Especially in the first essay, he gives ardent expression to his belief in all-encompassing unity of all living beings united by Grace of God, a unity which will eventually overcome the biological law of mutual destruction and survival of the fittest. Trubetskoi's fiery indictments of national states, of armaments races, and of war generally sound very topical today, even if some of his later pronouncements, influenced by the events of the First World War, seem to contradict his initial stand.

The three essays were originally published as individual articles before and during the First World War. They were first collected in a monograph by the YMCA Press in Paris in 1965. At that time, several university colleagues expressed an interest in a translation into English, and I felt strongly that students in many fields could profit by acquaintance with Trubetskoi's essays. That a translation was undertaken is owed to the dedicated enthusiasm of Katherine A. Hanfmann upon whose request Gertrude Vakar consented to translate the essays, while I acted as editorial advisor. We should like to thank Professors George Florovsky and Kurt Weitzmann of Princeton University and Mrs. Jelisaveta S. Allen of Dumbarton Oaks Center

for Byzantine Studies who have generously answered various questions. We are deeply grateful to Reverend John Meyendorff of St. Vladimir's Orthodox Theological Seminary. He encouraged us to proceed with the project and we are indebted to his helpful initiative for the privilege of having this translation published by St. Vladimir's Press. It seemed useful to include with the Essays an Appendix and Bibliography which will guide the reader to some books on icons, on Russian art, and on the background of the most important Russian icons, which have now been relocated in State Collections and Museums.

GEORGE M. A. HANFMANN

Harvard University

Foreword to the Russian Edition

Prince Evgenii Nikolaevich Trubteskoi (September 23, 1863-January 23, 1920, Old Style) was an outstanding Russian philosopher and a very gifted writer. He gave us the first, and so far the only, comprehensive artistic, historical, and theological interpretation of the old-Russian icon.

This book contains Prince Trubetskoi's public lectures on the Russian icon. The first two—"A World View in Painting" and "Two Worlds in Old-Russian Icon Painting"— were published as monographs in 1915 and 1916 and immediately became widely known. Never republished, they are now bibliographical rarities. The third lecture, "Russia in Her Icons," appeared at the height of the Revolution, in one of the last issues of the Journal *Russkaia Mysl'* (January/February, 1918) and consequently remains almost unknown.

A World View in Painting

I

The meaning of life may never have been a more pressing issue than it is today, when the world's evil and senselessness stand exposed for all to see.

I am reminded of visiting a cinema in Berlin, some four years ago, and seeing a film on the life of a predaceous water beetle in an aquarium. It was a vivid illustration of the ruthless struggle for survival that goes on in nature. Creatures were shown devouring one another, and the beetle invariably got the better of fishes, mollusks, salamanders, and so on, thanks to the technical perfection of two weapons: the powerful mandibles with which it crushed its victims, and the toxic substance with which it poisoned them.

Such has been the way of nature for eons, and such it will be for an indefinite time to come. If the spectacle repels us, if we experience a sense of moral nausea at the sight of such scenes as were filmed in the aquarium, this proves that in man there exist the seeds of another world, a different *plane of being*. It would not be possible for us to feel so revolted if this animal life were the only kind of existence we could imagine, if we did not feel an inner call to bring about a different way of life.

13

A higher call, appealing to his *consciousness and will,*
is opposed in man to the unconscious, blind, chaotic life
of nature. As yet it is no more than a *call.* In fact, we can
see that man's mind and will are being degraded to the
point of serving the animal instincts they are intended to
combat. Hence the horrors we are witnessing today.

Our moral revulsion reaches its height when we realize
that despite the higher call human life is very like those
events in the aquarium. In times of peace this fatal re-
semblance is hidden, plastered over by culture, but as soon
as nations engage in armed struggle it appears with cynical
frankness: culture not only fails to hide it but *emphasizes*
it, for in times of war culture itself becomes an instrument
of evil, of predatory aggression, and is used for much the
same ends as the mandibles of the water beetle. The prin-
ciples that obtain in the animal world come to govern man-
kind. Slogans like "Woe to the vanquished" and "Might is
right," proclaimed as guiding rules in the life of nations,
are nothing but biological laws elevated into principles of
conduct.

This transformation of laws of nature into moral prin-
ciples, the elevation of biological necessity to the status of
ethical fundamentals, denotes the essential difference be-
tween the animal and the human worlds—and the com-
parison is not in favor of man.

Among animals, the perfection of deadly weapons be-
speaks merely an *absence* of spiritual life: these weapons
are gifts of nature, independent of their consciousness and
will. In the human world they are, on the contrary, inven-
tions of the mind. We can see entire nations concentrating
on one primary aim—to create big mandibles for themselves
with which to crush and devour other nations. The sub-
jugation of the human spirit to gross material interests is
shown most clearly by the power of this single aim over
our lives—an inescapable power, for the pursuit of this aim
becomes mandatory: as soon as one aggressor appears on
the scene, one nation wholly devoted to perfecting the
techniques of destruction, other nations must follow suit
since a lag in armaments could mean their undoing. All

must have mandibles at least equal in size to the aggressor's. In some measure all must assume the image of the beast. This degradation of mankind is the main, intrinsic horror of war, before which all its other horrors pale. Even the rivers of blood are a lesser evil!

All this raises with sharp immediacy the question that always was the basic question for man—that of the meaning of life. Essentially, it is always the same; it does not change with changing conditions. But it is most sharply posed and perceived when the evil forces prevail that seek to turn the world into bloody meaningless chaos.

For countless centuries, hell has ruled the world—the fatal need for murder and death. What has been done about it by man, that witness for a higher design, the hope of all creation? Instead of fighting this "reign of death," he has said, "Amen." Hell rules the world with his consent and approval. Yet man is the only creature able to combat it, for hell is armed with the resources of human technology. Nations devour one another; a nation armed to destroy everyone else is the ideal that periodically triumphs in history, and every time its triumph is heralded by one and the same paean to the winner: "Who is like unto the beast?" [Rev. 13:4]

If indeed this apotheosis of evil is the crown of all human life and all human history, where is the meaning that makes life worth living? I shall not try to answer this question myself. I would rather remind the reader of the answer given by our forebears. They were not philosophers, they were seers, and they put their thoughts into colors, not words. Their painting directly answers our question, for in their lifetime, too, the meaning of life was a burning question. The horror of war that we feel so keenly today was a chronic evil in their times. The countless hordes ravaging Russia were a constant reminder of the "image of the beast." The kingdom of the beast even then tempted people with the same eternal bait: "All these things will I give thee, if thou wilt fall down and worship me." [Mat. 4:7]

The ancient religious art of Russia grew out of the struggle against this temptation. The old-Russian icon

painters countered it with striking power and clarity by
embodying in images and colors the vision that filled their
souls—the vision of a different truth of life, a different
meaning of the world. I shall try to express in words the
gist of their answer, though I know, of course, that no words
can convey the beauty and power of their incomparable lan-
guage of religious symbols.

II

The truth which our old religious art opposes to the
image of the beast finds its full expression not in this or
that icon but in the old-Russian church as a whole. The
church is seen as the principle that must rule the world. The
whole universe must become a temple of God. All creatures—
man, angels, animals—must come into its fold. In this idea
of a world-embracing church rests the religious hope for
peace among all creation, as against universal war, universal
bloodshed and trouble. Let us try to trace the development of
this theme in old-Russian religious art.

In this art the world-encompassing church is not yet a
reflection of reality. It is the ideal, the still unattained hope
of all creation. In the world as we know it, the lower orders
and most of mankind stand as yet outside the church. There-
fore the church embodies a *different* reality, the heavenly
future that beckons but has not been reached. The architec-
ture of our ancient churches, especially the Novgorod ones,
expresses this with incomparable perfection.

On a cold clear day not long ago, finding myself on the
outskirts of Novgorod, I saw all around me an endless
desert of snow—the best possible image of our earthly
poverty. Above it, like distant symbols of otherworldly
riches, glowed the golden domes of white churches against
the deep blue of the sky. I have never seen a better illustra-
tion of the religious idea that is embodied in the Russian
bulb-shaped, pointed dome. Its meaning will become clearer
if we compare this dome with other architectural solutions.
The dome of Byzantine churches represents the firma-

ment covering the earth like a lid. The Gothic spire, on the
other hand, represents an irrepressible upward surge lifting
a huge mass of stone from earth to heaven. Finally, our
national "bulb" represents a deep prayerful yearning toward
heaven, a flame of prayer, as it were, through which our
earthly world participates in otherworldly riches. The Russian
dome is like a tongue of flame topped by a cross, pointed
toward the cross. Looking at the Ivan Velikii belfry in
Moscow, we see, as it were, a gigantic candle burning to
the Moscow skies. The many-domed Kremlin cathedrals
and churches are like enormous candle holders full of
candles. And it is not the golden domes alone that express
this idea of surging prayer. When you look from afar, in
bright sunlight, at an old Russian monastery or a city with
many churches, all of it seems to glow with multicolored
lights. And when these lights sparkle distantly in a great
field of snow, they draw you like a faraway, otherworldly
vision of the City of God. All the attempts to explain our
bulbous domes by utilitarian reasons (for example, that
the pointed roof prevents snow and water from accumulat-
ing on it) fail to explain the most essential, their religious-
esthetic meaning. There are many ways, including the steep
Gothic spire, of getting the same practical results. Why
then, from among all the possible ways, did the old-Russian
architects choose to crown their churches with a bulb-shaped
dome? Evidently because its esthetic effect corresponded to
a certain religious mood. This religious-esthetic mood is
well rendered by the folk saying about church domes, "they
glow like fire" *[zharom goriat]*. As to explaining our dome
by "Eastern influences," whatever their degree of likelihood,
it obviously does not exclude the interpretation given here,
since the same religious-esthetic motive may well have in-
fluenced Near Eastern architecture.

It should be noted that the inner and outer shapes of
the Russian dome express two different sides of the same
religious idea; this combination of different aspects of re-
ligious life is a very interesting feature of our ancient
church architecture. Inside, the pointed dome retains the
traditional meaning of any dome, that is, it represents the

motionless vault of the sky. How is this reconciled with
that air of ascending flame that it has outside?

A little reflection will convince us that what we see here
is only a seeming contradiction. The architecture of the
interior expresses the ideal of the all-embracing church where
God Himself resides and beyond which there is nothing.
Naturally the dome represents the highest, extreme limit
of the universe, the crowning celestial sphere where the
Lord of Sabaoth reigns. The outside is a different story:
There, above the church, is the real sky, a reminder that the
earthly church has not yet reached the highest sphere. To
reach it, a new surge, a new fervor are needed. That is why
the same dome assumes on the outside the mobile form of
an upward-pointing flame.

Need I say that the interior and the outside are in
perfect harmony? It is through the flame that heaven
descends to earth, enters the church, and becomes the ul-
timate completion of the church, the consummation in
which the hand of God covers everything earthly, in a
benediction from the dark blue dome. God's hand, vanquish-
ing the world's discord, leading to universal community,
holds the destinies of mankind.

This thought is reflected in a curious way in the ancient
Novgorod cathedral of Saint Sophia (11th century). The
artists did not succeed in painting in the main dome the
Saviour's hand raised in blessing: despite all their efforts,
it came out as a closed fist. According to legend, the work
was finally stopped by a voice from heaven, which forbade
further correction and announced that the Saviour's hand
held Novgorod itself: If the fist opened, the city would
perish.

A variant of this theme can be seen at the church of the
Assumption *[Uspenie]* in Vladimir-on-the-Kliazma, in a
fresco by the famous Rublev, showing "the righteous in
the hand of God": many haloed saints are held in a
powerful hand at the apex of the celestial dome, and the
righteous throng toward this hand from all directions, in
response to the call of angels trumpeting upward and
downward.

Thus the church affirms the inner communal unity
destined to overcome the chaotic divisions and enmity in
the world and in man. A *sobor*[1] of all creatures as the
coming universal peace encompassing angels and men and
every breathing creature of the earth—that is the basic idea
of the church, which dominated both our ancient religious
architecture and our religious painting. Saint Sergius of
Radonezh himself expressed it quite consciously and in a
remarkably profound way. Having founded his monastic
commune, Saint Sergius, according to his biographer, "erect-
ed a church to the Trinity, as a mirror for those he had
gathered into a community, so that the sight of the Holy
Trinity might vanquish the fear of the world divided by
hate." Saint Sergius was inspired by the prayer of Christ
and his disciples, "That they may be one even as we are
one" [John 17:22]. His ideal was the transfiguration of
the world in the image of the Holy Trinity, that is, the
inner union of all beings in God. All of ancient Russian
religiosity, including our icon painting, lived by this ideal.
Overcoming hateful discord, transforming the world into a
church uniting all creation as the Three Persons of the
Holy Trinity are united in one Godhead—to this basic
theme everything in old-Russian religious painting was
subordinated. Before discussing the special language of its
symbolic representations, we must touch upon the main
obstacle that until now has made it hard for us to under-
stand.

There can be no doubt that our icon painting expresses
the deepest concerns of old-Russian culture. Moreover, our
ancient icons are among the greatest treasures of religious
art in the world. Yet until quite recently they were incom-
prehensible to the educated Russian. He hardly gave them
a passing glance. He simply could not distinguish the icon
behind the age-old deposits of smoke and grime. Only in
the very recent past have we become aware of the extra-
ordinary beauty and brightness of its colors. Only now,
thanks to astonishing progress in cleaning techniques, can

[1]*Sobor* means both "cathedral" and "gathering," "assembly." *Translator.*

we behold these colors of bygone ages, and the myth that the icons were dark to begin with is laid to rest. It turns out that the darkened faces of saints in our old churches were due to our indifference and neglect, and partly to lack of skill: we did not know how to take care of our treasures.

With our ignorance of the original colors of icon painting went a total misunderstanding of its spirit. In a one-sided interpretation, its main trend was described by the vague term "asceticism" and brushed aside as old-fashioned. At the same time, the Russian icon's most significant trait, the incomparable joy it proclaims to the world, went unnoticed. Now, when the icon has turned out to be one of the brightest creations of painting of all time, we often hear of its extraordinary joyousness. Yet we cannot deny the presence of asceticism, and this faces us with one of the most interesting riddles ever put to art critics. How is asceticism reconciled with the brilliant colors? What is the secret behind this conjunction of deepest sorrow and highest joy? Unraveling the mystery means finding the answer to the main question posed in this paper—that of the meaning of life as understood and expressed in our ancient icons.

Undoubtedly we have here two intimately related sides of the same religious idea. There can be no Easter without Passion Week, and to reach the joy of universal resurrection one cannot bypass Christ's life-giving cross. That is why the joyous and the sad, *ascetic* motifs in our icon painting are equally necessary. I shall begin with the latter, because in our time it is the asceticism of the icon that mainly impedes its understanding.

In the seventeenth century, when, along with other reforms, realistic painting on the Western model invaded Russian churches, the famous Archpriest Avvakum in a remarkable letter spoke out against it and in favor of the ascetic spirit of old icon painting:

> God has seen fit to suffer a proliferation of improper icon painting in the Russian land. The painters paint, and the authorities look upon them with favor, and all walk to the pit of perdition, hanging on to one another. They paint the

image of Emmanuel the Saviour with puffy face, red mouth, curly hair, thick arms and muscles; the legs, likewise, have fat thighs, and the whole is done like a German, only the saber at the hip is not painted in. And all this has been thought up by that fiend Nikon, to paint [icons] like living people.... The old, good painters painted the saints' likenesses differently: refining the face and hands and all feelings, emaciating through fast and toil and many sorrows. Whereas you have now changed their likeness, you paint them such as you are yourselves.

Avvakum gives us here a clasically precise description of one of the two main aspects of old-Russian icon painting—the sorrowful, ascetic aspect; but we must keep in mind that it played a subsidiary—and preparatory—role. More important, of course, was the joy of the final victory of man-God over man-beast, the gathering of all mankind and all other creatures into the church. But man must prepare for this joy by strenuous efforts, he cannot become a part of God's church in his present state. There is no room in that church for the uncircumcised heart, the fat, complacent body. *That is why icons must not be painted from living people.*

An icon is not a portrait but a prototype of the future man-within-the-church. Since we cannot yet see this man but *only divine* him in the present sinful people, an icon can represent him only symbolically. What does the attenuated body mean? It means outright rejection of the "biologism" that makes the body's gratification an absolute law justifying not only man's grossly utilitarian and cruel view of the lower creatures but also the right of any nation to wage bloody war on other nations if they happen to prevent it from getting its fill. The gaunt faces of saints in the icons oppose to this bloody reign of sated flesh not only "refined feelings" but also, and above all, a new norm of relationships. That is the kingdom that flesh and blood cannot inherit.

Abstention from food, especially meat, has a double purpose. First, mortification of the flesh is an absolute requirement for spiritualizing man's image; second, in doing so, it also prepares the coming peace among men and be-

tween men and other creatures. The old-Russian icon mar-
velously expresses both these ideas. For the time being, let
us concentrate on the first. A superficial observer may find
the ascetic faces dry and lifeless. Actually, however—and
this is due to the very ban on "red mouths" and "puffy
faces"—spiritual life shines through with incomparable
power, despite the traditional strict conventions of form
that limit the artist's freedom. It may seem that the canon
prescribes almost everything—not just inconsequential de-
tails but also the most essential traits: the position of the
saint's body, and that of his crossed arms in relation to
each other, and the way his fingers are folded in benedic-
tion; the extremely restricted movement; the exclusion of
anything that could make the Saviour and the saints look
"like unto ourselves." Where movement is permitted, it is
bound by rigid, immovable limits and, as it were, arrested.
But even when it is entirely absent, the artist still has a
free hand with the saint's eyes, their expression—that is,
the very trait of the human face in which spiritual life
most intensely concentrates. It is in the treatment of the
gaze that the supreme creativity of religious art emerges in
all its power, bringing the fire down from heaven to
illumine from within the saint's human form, no matter
how static it may seem. At the Museum of the Archives
Commission in Vladimir-on-the-Kliazma there is a silk-
embroidered image of the Great-Martyr Nikita, the work,
according to legend, of Anastasia, wife of Ivan the Terrible,
born a Romanov. I have never seen a more powerful ex-
pression of holy sorrow for the sins and sufferings of all
the world's creatures. Other outstanding examples of sor-
rowful countenances are in I. S. Ostroukhov's collection in
Moscow, in an icon of Saint Simeon and an icon of the
Entombment. In the latter, the Virgin's grief is rendered
with a power that may be equalled only in the works of
Giotto or other masters of Florentine art at its highest. At
the same time, we also find in old-Russian icons inimitable
renderings of such moods as ardent hope or quiescence in
God.

For many years I remained strongly impressed by

Vasnetsov's famous fresco "The Righteous Rejoicing in Christ" at the Kiev cathedral of Saint Vladimir (sketches for it can be seen at the Tretiakov Gallery in Moscow). I confess that this feeling waned after I had seen Rublev's treatment of the same theme at the cathedral of the Assumption in Vladimir-on-the-Kliazma. The superiority of the ancient fresco over Vasnetsov's is characteristic of our old icon painting. In Vasnetsov, the righteous flying to paradise look too natural: their flight is a physical motion; their bodies as well as their thoughts seem intent on reaching heaven. This, and the unhealthy hysterical expression of some of the faces, makes the whole fresco too realistic for a church and thus weakens its impact.

Rublev's fresco is quite different. An extraordinary, concentrated fervor of hope is conveyed solely by the forward gaze of the eyes. The crossed arms of the righteous are motionless, as are their torsos and legs. That they are proceeding toward paradise is shown exclusively by the eyes, which express no hysterical exaltation but a deep inner ardor and the calm certainty of reaching their goal. The seeming *physical* immobility is precisely what conveys to us the tension and power of ceaseless spiritual ascent. The less the body moves, the better do we perceive the movement of the spirit, for the corporeal world becomes its transparent shell. By expressing spiritual life with *nothing but the eyes* of a perfectly motionless figure, the artist symbolically conveys the immense power of the spirit over the flesh. One gets the impression that all corporeal life is stilled, waiting for the highest revelation, listening for it. And this is the only way to hear it: first must resound the call, "Be silent all flesh" [Zech. 2:13]. Only when this call has been heard does man's image become spiritualized: *his eyes open.* They not only open on another world, they open that world to others: it is this combination of complete immobility of the body with the spiritual meaning of the eyes, so frequent in our best icons, that makes an overwhelming impression.

It would, however, be wrong to assume that all human figures in our old icons are motionless. Immobility goes

only with a certain state of grace, when the human image is filled with divine content, when, in one way or another, it enters the motionless calm of divine life. Humans out-side the state of grace, or in a state preceding grace, not yet "becalmed" in God or simply not yet having reached the goal of their life's journey, are often depicted in very strong movement. Typical in this respect are many Novgorod renderings of the Transfiguration: The Saviour, Moses, and Elijah are motionless, but the smitten apostles, in their purely human fright before the heavenly thunder, display a striking variety of body movements. On many icons they appear lying literally upside down. The remarkable icon "The Vision of Saint John Climacus" at the Alexander III Museum in Petrograd shows even bolder movement: sinners falling headlong from the ladder leading to paradise. Im-mobility in icons is an attribute of those images where not only the flesh but all human nature is silenced, where it no longer lives its own life but a *suprahuman* life.

Needless to say, this state does not mean cessation of life but, on the contrary, its highest intensity. Only a non-religious or superficial mind will find the old-Russian icons lifeless. There may be a certain coldness and abstractness in old Greek icons, but the Russian icons are their very opposite in this respect. For convenient comparison, it is useful to visit the Alexander III Museum in Petrograd, which has a Greek room next to four Russian rooms. One is struck by the warmth of feeling that suffuses the works of the Russian icon painters and was foreign to the Greeks. The same is true of the Ostroukhov collection in Moscow, with its Russian icons next to Greek ones or the earliest Russian ones, which still follow the Greek prototypes. Russian icon painting, in contrast to the Greek, did not kill the life of the human face but gave it higher spirituality and meaning. What could be more immobile than the faces of the "Akheiropoietos Saviour" or the prophet Elijah in the Ostroukhov collection? Yet an attentive eye will recog-nize in them a spiritualized typically Russian face. Thus it is not only the universally human but also the national aspect of man that is brought into the motionless peace of God

and preserved in glorified form in these sublime works of religious art.

III

Speaking of the Russian icon's asceticism, we must touch upon another of its traits, organically linked to its asceticism. In intent, a church and its icons form an indivisible whole. Hence the icon is subordinated to the *architectural design* of the church. This explains the remarkable *architectural quality* of our religious painting. Subordination to architectural form is felt not only in the church as a whole but in every single painted image. Every icon has its special internal architecture, visible even apart from its connection with the church building.

The architectural design can be sensed both in individual figures and, especially, in groups, in icons representing an assembly of saints. The impression is reinforced by the immobility of divine repose in which the saints are immersed. It is largely by means of this immobility that our religious painting rendered a conception expressed by Saint Peter: Motionless or frozen in postures of veneration, prophets, apostles and saints surround Christ, the "living stone, rejected indeed of men, but with God elect," and themselves seem changed into "living stones, are built up a spiritual house" (I Peter, 2:4-5).

The architectural aspect more than any other deepens the chasm between ancient icon painting and realistic painting. We see human figures shaped to conform to the lines of a church, now too rectilinear, now unnaturally curved, to harmonize with the curve of a vault. The heavenward thrust of a narrow, tall iconostasis may call for extremely elongated figures; the heads then look disproportionately small for the bodies; the shoulders are unnaturally narrow, which emphasizes the ascetic emaciation of the whole image. And if your eye is accustomed to realistic painting, you always feel that these orderly rows of rectilinear figures crowd much too closely around the central figure.

Perhaps it is even more difficult for the untutored eye

to get used to the paintings' strict symmetry. Like every church, every icon depicting groups of saints has an architectural center, which coincides with the ideological center. On both sides of it the saints are invariably grouped in equal number and often in identical postures. The center may be the Saviour, the Virgin, or Saint Sophia the Divine Wisdom. Sometimes, for the sake of symmetry, even the central image is doubled. Thus, in ancient icons of the Eucharist, Christ is depicted twice, handing the apostles bread on one side and the holy chalice on the other. He is approached on both sides by symmetrical rows of apostles, uniformly bent over in his direction.

Even the names of some icons refer to architectural notions, for instance, "The Virgin of the Indestructible Wall" at the Kiev cathedral of Saint Sophia; and the Virgin's raised arms seem to support the vault over the main altar. The architectural style is especially apparent in those icons which themselves resemble a small iconostasis. Among them are such icons as "Sophia the Divine Wisdom," "The Protection of the Holy Virgin" *[Pokrov]*, "In Thee Rejoices, Gladdened, All Creation," and many others in which we invariably find symmetrical groups around the main figure. In the Sophia icons, we see the symmetrical figures of the Virgin and John the Baptist flanking an enthroned "Sophia," and the symmetrical shape and movement of angel wings. In the above-mentioned icons of the Virgin, the architectural idea emerges not only in the symmetrical figures surrounding her but also in the representation of a cathedral in the background. The symmetry here expresses neither more nor less than the communal oneness of men and angels: their individual lives are subordinated to the *communal* plan.

This idea accounts for much more than composition in icon painting. The subordination of painting to architecture is not determined by external, fortuitous considerations of architectural convenience. The architectural character of the icon expresses one of its central, essential ideas, the idea of universal communality *[sobornost']*. The dominance of architectural lines over the human form expresses man's subordination to the communal, the preponderance of the

universal over the individual. Man here ceases to be a self-contained person and submits to the *overall* design. Icon painting affords us a vision of the coming church-enclosed humanity. It must perforce be represented symbolically since universal communal unity has not been attained: it exists on earth only in an embryonic state. Strife and chaos still reign in the human world; it is not a united church of God. To lead mankind into that church and create true communion, "fast and toil and straitness and great sorrows" are needed.

From the icon's sorrow we shall now pass to its joy, which can be understood only in connection with its sorrow.

IV

As Schopenhauer has said, great paintings should be approached like royalty. It would be impertinent to speak to them; one must stand before them and deferentially wait for them to speak to us first. This is especially true of icons, for an icon is more than a work of art. We must wait a long time before it will speak across the immense distance that separates us.

A sense of distance is our first impression when we visit old churches. Something in the stern images both attracts and repels us. The fingers folded in blessing beckon to us and at the same time bar our way. To heed their call, one has to renounce a large part of life, the part that is dominant in the world.

What is this repellent force in the icon, and what precisely does it repel? I understood it more tangibly than before when I happened to visit The Hermitage too soon after looking at icons at the Alexander III Museum in Petrograd. The sight of Rubens's bacchanalia made me feel sick to my stomach, and this feeling clarified for me the forbidding effect I had been thinking about, for a bacchanal is the extreme expression of the life that the icon rejects. Fat, shaking flesh delighting in itself, gorging on meat and necessarily killing in order to gorge—this was the very thing

that the blessing fingers repel. But they do more: they demand that we leave behind all trivial concerns, because "earthly concerns," which the church enjoins us to "lay aside," also serve the dominance of sated flesh. So long as we are beguiled by the delights of the flesh, the icon will not speak to us. When it does speak, it will be to announce the highest joy—the suprabiological meaning of life and the end of the beast's kingdom.

Our religious art expresses this joy not in words but in marvelous colorful visions. The brightest and happiest of these is the one that reveals in all its fullness the new understanding of life that will replace the cult of the beast— the vision of the all-embracing church. Here sorrow itself is transmuted into joy. As I have said, in icons the human image, as it were, sacrifices itself to the architectural lines. And suddenly we can see that this sacrifice is justified: the architecture of the church carries man to the approaches of heaven. Allow me to clarify this thought with a few examples.

Our religious painting presents the ascetic idea perhaps most cogently in the images of John the Baptist; yet the name of that saint is also attached to one of the most joyful monuments of our religious architecture, the church of John the Precursor in Iaroslavl. Here it is easiest to trace how sorrow and joy blend into one organic whole.

As I have had occasion to mention elsewhere, both motifs appear in the images of the saint himself. On one hand, as the Precursor of Christ, he personifies renunciation of the world. He prepares mankind for the new meaning of life by preaching repentance, fasting, and all kinds of abstinence. This idea is conveyed by his gaunt face, his unnaturally thin arms and legs. On the other hand, the very exhaustion of the flesh gives him the strength for joyous spiritual flight: this is shown by his great beautiful wings. The rise to supreme joy is expressed in the whole architecture of the church, in its colorful ceramic tiles, in the patterns of imaginative ornaments with lovely fantastic flowers climbing the outside columns of the building, up and up to its glowing, golden, flame-like domes. We find a similar blend of asceticism with almost unbelievable,

unearthly colors in the Moscow church of Basil the Blessed. Both these churches speak of beatitude grown out of suffering, of the new, church-like architecture of the world, rising above human sorrow as it carries everything aloft, spiraling to the domes, and bursting into heavenly flowers on its way.

This architecture is also a sermon: it preaches the new style of life that is to replace the bestial style; it presents a positive, lofty alternative to biologism and its unlimited power over the low orders and over man; it expresses the new harmony that will end the bloody struggle for survival and gather all creatures into the church, with man at their head.

This idea is developed in a great many icons and works of architecture, leaving no doubt that the ancient Russian church was understood as a gathering not just of angels and saints but of *all creatures*. Especially remarkable in this respect is the Saint Demetrius cathedral in Vladimir-on-the-Kliazma (12th century). Its outer walls are covered with sculptured animals and birds amid a luxuriant vegetation. These are not realistic animals but idealized, beautiful images, whose spiritual meaning is made clear to us by the presence of King Solomon in their midst: he presides here as the herald of the Divine Wisdom that has created the world. It is in this role that he gathers all creatures around his throne. They are not the animals we know *now* but those envisioned by God in his wisdom—that is, glorified and gathered into the church, into a living as well as architectural whole.

Many icons take up this theme, for instance, the series "Let All Breathing Things Praise the Lord," "Praise the Name of the Lord," "In Thee Rejoices, Gladdened, All Creation." Here, too, we see all terrestrial creatures together, in a glorified vision of romping animals, singing birds, and even fishes swimming in the sea.[2] In all these

[2]E.g., the carved icon *Vsiakoe dykhanie* ("All Breathing Things") in the Ostroukhov collection, the *Khvalite* ("Praise the Name") at the Alexander III Museum in Petrograd. *Cf.* the description of the *O Tebe raduetsia* ("In Thee Rejoices") icons in the *Siiskii ikonopisnyi podlinnik* ("Pamiatniki drevnei pis'mennosti," Vol. IV, 1898, pp. 170, 180).

icons, the architectural design to which *all creation* submits
is represented by the image of a church, a *sobor.* Angels
stream toward it, saints assemble in it, plants of paradise
entwine it, and animals swarm before or around it. How
closely this joyful motif in our icons is related to the
ascetic motif is clear to anyone in the least familiar with
Russian or Greek hagiography. There, too, animals often
surround a saint and trustingly lick his hands. According
to Saint Isaac the Syrian this is the original relationship
that existed in Eden between man and beast. The animals
flock to the saint because they smell on him the odor that
Adam exuded before the fall. In man the change of attitude
goes even deeper. The narrowly utilitarian view of animals
as food or beasts of burden gives way to the new con-
ception of the world, in which they are the younger brothers
of man. Abstention from meat and a loving, deeply com-
passionate approach to all creatures are but two sides of
the same new truth, the truth that is counterposed to the
narrowly biological view of life. The essence of this new
conception of the world cannot be better expressed than in
the words of Saint Isaac the Syrian. This is how he speaks
of the loving heart:

> . . . man's heart aflame for all creation, for man, birds, animals,
> demons, and all creatures. As he thinks of them, or looks
> upon them, man's eyes flow with tears. From the great and
> strong pity that grips his heart, and from the great suffering,
> his heart is wrung, and it cannot endure, or listen to, or look
> upon, any harm or the smallest sadness suffered by a creature.
> Therefore he prays incessantly in tears for the mute ones too,
> and for the enemies of truth, and for those who do him
> harm, that they may be kept safe and be forgiven; and also
> for the creeping things he prays with great pity, which is
> roused without measure in his heart, even to likening him
> in this unto God.[3]

These words tell us concretely about the new plane of
being where the law of mutual gobbling is overcome at its
very root, *in the heart of man,* through love and compas-
sion. Conceived in man, the new relationship extends to

[3]*Izhe vo sviatykh ottsa nashego avvy Isaaka Siriianina,—slova pod-
vizhnicheskie* (Moscow: 1858), p. 299.

the lower orders. A cosmic revolution takes place: *new creatures* originate in man's love and pity. These "new creatures" are shown in the icons: through the prayers of saints, God's church opens its portals to them, gives a place to their spiritualized image. Among the attempts to render this vision of spiritualized animals, I should like to mention particularly the icon "Daniel in the Lions' Den" at the Alexander III Museum. To an untrained eye it may seem naive and the lions impossibly unrealistic as they gaze at Daniel with touching devotion. But in art the naive often borders on genius. Actually, the unlikeness here is quite appropriate and probably intentional. These lions are not supposed to look like the animals we know. They prefigure the new creatures, already aware of having come under a new, not the biological, law. It was the artist's task to depict a new way of life, still unknown to us, and of course he could do this only symbolically, not by copying *our* reality.

This symbolic style is especially moving in the icons that directly contrast the two worlds—the ancient cosmos enslaved by sin and the all-embracing church where this slavery is forever abolished. I have in mind the "King Cosmos" icons, a frequent theme in ancient Novgorod painting. Examples can be seen at the Alexander III Museum in Petrograd and in the Old Believers' church of the Assumption in Moscow. These icons are divided into two parts. In the lower part a prisoner languishes under a cellar vault—King Cosmos, wearing a crown; the upper part depicts Pentecost: tongues of flame descend on the apostles seated on thrones in a church. From the very fact that Pentecost is counterposed to *King Cosmos* it is clear that the church in which the apostles are enthroned is seen as the *new universe* and *new kingdom*—the *cosmic ideal* that is to liberate the actual cosmos. In order to receive the royal prisoner, the church must coincide with the universe, must encompass not only a new heaven but also a new earth. The tongues of flame above the apostles show us what is understood as the force that must bring about this cosmic revolution.

We have come to the central idea of all Russian icon painting. As we have seen, it subordinated all the separate creatures—men, angels, animals—and even the world of plants—to the *common* architectural design: what we have here is the *communality* of creatures within the church. But the church holds them together not by walls or architectural lines: the unity of the church is not imposed from outside; it is a living whole, drawn together by the Spirit of love. The unity of this church architecture comes from the new center of life, around which all creation gathers and *itself* becomes the church of God. Because it gathers around Christ and the Virgin, the Holy Ghost comes to dwell in it. And it is the image of Christ that gives all this painting and architecture its central meaning. The creatures gather in his name, and their union represents the *kingdom of Christ* united from within, in contrast to the disunited kingdom of "King Cosmos," decayed from within. Christ's kingdom is united by the life-giving communion of flesh and blood. That is why a representation of this communion, an icon of the Eucharist, so often occupies the central place in the altars of old churches.

If in its images of Christ, the God-man, our icon painting reveres the new meaning of life that must suffuse everything, the images of the Virgin—the Queen of Heaven, the helper and intercessor—personify the loving maternal heart, which becomes the universal heart through its burning to God, as she gives birth to God. Old-Russian icon painting reaches the height of religious inspiration and creative art in the icons that show the whole world gathered around the Virgin. Especially remarkable in old Novgorod icons is the treatment of two motifs—"In Thee Rejoices, Gladdened, All Creation," and "The Virgin's Protection" [*Pokrov Bozh'ei Materi*].

The first group, as its name implies, stresses the Virgin's cosmic significance. She is the joy of *all creation*. Behind her, across the width of the icon, is a beautiful cathedral with glowing golden domes or dark blue ones spangled with stars. These domes touch the dome of heavens: there seems to be nothing above them in all that blueness but

the throne of God. The foreground is given over to *the joy of all creation,* the enthroned Virgin with the holy Infant. Representing the joy of celestial beings, angels form a many-hued garland over her head. Below, human figures stream toward her from all sides—saints, prophets, apostles, and virgins personifying chastity. Paradisial plants encircle the church. In some icons, animals share in the rejoicing. To sum up, the idea of the world-encompassing church is brought out in its full meaning; we see before us not cold, indifferent walls, not an outer architectural design that encloses everything within it, but a spiritualized church, joined together by love. This is the true and full answer of our religious painting to the ancient temptation of the beast's kingdom. The world is not chaos; endless bloody strife is not its natural order. There is the loving maternal heart, destined to gather the world around itself.

In the "Protection" icons, too, the Virgin reigns at the center, with a church in the background. She is enthroned on clouds, which sometimes end in an eagle's beak, suggesting that they too are animate. Angels approach from all directions, extending a veil *[pokrov]* over her and over the saints at her feet. This veil overarching everything gives these icons their special shade of meaning. At the Alexander III Museum in Petrograd there is a fifteenth-century icon of the Novgorod school, in which the theme is treated with surpassing art. It conveys more than the gathering of mankind *under* the Virgin's protection. A spiritual fusion occurs between the extended veil and the saints in their multicolored garments, assembled under it. It is as if the saints formed an animate veil, illumined by their eyes shining from within like points of fire. These icons of the Virgin clearly disclose the joyous meaning of their picturesque architecture and symmetry. Not only the formal distribution of figures is symmetrical but also the *spiritual movement* that shines through their apparent immobility. Toward the Mother of God as the immovable center of the universe, the symmetrical strokes of angel wings converge from both sides. The human eyes are centered on her, and because of the immobility of the figures this

convergence of all gazes in one point gives the impression
of an irresistible universal turn toward the rising sun of
the world. This is no longer ascetic submission to the
symmetry of architectural lines but a centripetal movement
toward universal joy. It is the symmetry of a spiritualized
rainbow around the Queen of Heaven, as if the light that
flows from her, having passed through the angelic and the
human spheres, were refracted in a multitude of colors.

In many ancient Novgorod, Moscow, and Iaroslavl
icons it is Saint Sophia the Divine Wisdom who appears
in this role of architectural center and source of light. The
heavenly host—the angels that form, as it were, a crown
above her—and humanity, personified by the Virgin and
John the Baptist, surround her throne. In this discourse
I shall not enlarge upon the religious-philosophical mean-
ing, which I have discussed elsewhere, of these icons; suffice
it to say that in their spiritual meaning they are very like
those of the Virgin. In a purely artistic sense, the latter are
superior. This is understandable: Sophia the Divine Wisdom
represents the still undisclosed mystery of God's design
for the world, whereas the Virgin, having gathered the
world around the holy Infant, represents the realization
and revelation of God's design. It is this assembled, united
universe that God in His wisdom has envisioned; it is what
He wanted; and it will overcome the chaotic kingdom of
death.

V

In conclusion, let me return to the question I raised
at the beginning. I said that the meaning of life, essentially
the same through the ages, becomes an especially burning
issue during periods when the senseless vanity and un-
bearable torment of our life are *totally* exposed.

All of Russian icon painting is really an answer to the
limitless sorrow of existence, the one expressed in the
words, "My soul is exceeding sorrowful, even unto death"
[Mat. 26:38]. Only now, in these days of world war, have
we come to feel all the pain of that sorrow. But for the

same reason we are better able to understand the gripping drama of the icon. Only now does its joy begin to reach us, because we cannot live without it after all the suffering we have endured. At long last, it is brought home to us how dearly this joy has been bought, how much suffering of the Russian people's soul the icon has seen over the centuries, how many tears have been shed before it, and how imperiously it answers these tears.

In the early autumn of this year something like the end of the world was going on in our part of the country. The enemy was advancing with the speed of a storm. Millions of hungry refugees treking eastward reminded us of the Gospel's words about the last days of the world: "Woe unto them that are with child and to them that give suck in these days! And pray ye that your flight be not in the winter . . . for then shall be great tribulation, such as hath not been from the beginning of the world, no, nor ever shall be" (Mat. 24:19-21). What we felt then—and feel now, in the days of our winter tribulations—must come close to the feelings of ancient Russia during the Tatar invasion. And look at the result! The icon, silent for centuries, has begun to speak to us, in the language in which it spoke to our distant forebears.

In late August, prayer services for a victorious end to the war were held throughout the country. Under the impact of anxiety, the attendance in our village was unusually large and the mood of the congregation very fervent. In Kaluga Province, where I happened to be at the time, a rumor among peasants had it that Saint Tikhon himself— the most revered saint in that region—had left his shrine and was walking the Russian land as a refugee. The church was crammed. Everyone joined in singing the prayer to the Holy Virgin. At the words, "We have no other recourse, no other hope," many wept, and the whole crowd prostrated itself at the Virgin's feet. I had never before heard a large congregation put so much feeling into these words. All these peasants had seen the refugees and were thinking of their own possible destitution, death from famine, the

horrors of winter flight. No doubt they felt that without
the Virgin's protection they would surely perish.

This is the mood that created the old-Russian church,
the mood that inspired the icon and that the icon answered.
Its symbolic language is incomprehensible to the sated flesh,
to the heart full of longings for material things. But it
becomes the very fabric of life when these longings collapse
and an abyss opens at our feet. Then we need a firm foot-
hold at the edge of the abyss, we need to feel the motion-
less calm of the icon above our tribulations. And the joyous
vision of a *sobor,* a church of all creation above the bloody
chaos of our existence becomes as necessary as our daily
bread. We need to be sure that the beast is not all in all;
that above the beast's kingdom there is another law of life,
and that it will prevail.

That is why in these sorrowful days the ancient colors
revive into which our forebears put a timeless content. We
feel in ourselves the strength that in past centuries drew
golden-domed churches out of the earth and lit tongues
of flame above the captive Cosmos. Ancient Russia found
this strength because "days of tribulation" were the norm,
and happy days rare indeed. Daily and hourly, the Russian
people was in danger of "dissolving in chaos," that is, simply
of being devoured by its neighbors.

After many centuries, chaos again knocks at our door.
The danger for Russia and the world is the greater because
today's chaos is complicated and, so to speak, sanctioned
by culture. The Mongol hordes—Pechenegs, Polovtsy,
Tatars—did not think about culture; they followed in-
stinct, not principles. They killed other peoples in order to
obtain food for themselves, as vultures do; they lived by
the biological law innocently, spontaneously, not even sus-
pecting that some higher norms might exist. Our present
enemies are different. In their camp, biologism is con-
sciously elevated into the principle that must rule the world.
Any suggestion that their right to kill could be limited by
some higher principle is swept aside as sentimental and
false. Here we have something worse than living like beasts.
We have conscious veneration of the image of the beast,

suppression in principle of all human charity and compassion. If this kind of outlook prevails in the world, humanity can expect worse things than the Tatar yoke. We have here an enslavement of the spirit unparalleled since the beginning of time, bestiality elevated into a principle and a system, renunciation of all the human values that have until now existed in culture. A victory of this evil principle may lead to the total extermination of entire peoples because other peoples may want their land.

Such are the dimensions of the struggle we are waging. Not only our own territorial integrity and independence are at stake but the salvation of everything that is human in man, the preservation of the very meaning of human life in face of the threatening chaos and meaninglessness. The spiritual struggle that lies ahead for us is immeasurably harder and more important than the armed struggle that is now bleeding us white. Man can no longer remain merely a man: he must rise above himself or fall into the abyss, become godlike or become a beast. At this moment in history mankind stands at a crossroads. It must definitely decide which way it will take, that of a zoological culture or that of the "loving heart" aflame with love for all creatures. Which will it be? Is the world destined to become a zoo—or a church?

The question itself fills us with deep confidence in Russia. We know which of the two she perceives as her national vocation, which view of the world is expressed in the finest creations of her popular genius, among which her religious architecture and painting unquestionably belong. In them the soul of the people manifests its most beautiful, intimate content—that limpid depth of religious inspiration that later appeared to the world in the classic works of Russian literature. Dostoevsky has said, "Beauty will save the world." Soloviev, developing the same theme, proclaimed the ideal of "theurgic art." When these words were spoken, Russia did not yet know what treasures of art she possessed. We already *had* theurgic art. Our icon painters had seen the beauty that would save the world and had immortalized it in colors. The thought of the *healing power of beauty*

has been alive for a long time in the idea of the miraculously revealed and miracle-working icon! Amid our present manifold struggle and boundless sorrow, let that power console us and give us courage. Let us affirm and love that beauty! It embodies the meaning of life which will not perish. Nor will the nation perish that ties its fate to this meaning. The world needs that nation to break the dominion of the beast and save humanity from grievous bondage.

Thus is resolved the seeming contradiction between our human wish for the victory of one nation over another and the ideal of icon painting, universal peace among all creatures. Russian history has repeatedly dealt with this problem in the most unambiguous way. In ancient Russia, no one desired peace more fervently than Saint Sergius, who built a church to the Trinity to represent the idea of overcoming the world's hateful division; yet he blessed Dmitrii Donskoi's armed struggle, and a powerful Russian state grew around his monastery! The icon predicts the end of war, yet icons have always been carried before troops and inspired them to victory!

To understand this, it suffices to ask one simple question: Could Saint Sergius have tolerated the profanation of churches by the Tatars? Can we now let the Novgorod or Kiev churches become German stables? Still more unthinkable, of course, is the extermination of entire peoples or the raping of all women in a conquered country. The icon's religious ideal would be untrue if it sanctioned the lie of nonresistance to evil, but luckily this lie has nothing in common with the spirit of the icon. It is, in fact, its direct opposite. When Saint Sergius proclaims the *supraterrestrial* union of all creatures and then blesses war here on *earth,* the two acts are not contradictory, because the peace of transfigured creatures in the eternal calm of God and our war against the dark forces that retard the realization of this peace unfold on different planes of being. The holy war does not jeopardize peace—it *prepares its coming.*

A telling passage in the Book of Revelation describes the temporary chaining of Satan so that he "should deceive the nations no more." This image answers our doubts. If

the future universe is to be a church, it does not follow that Satan must be allowed to establish his kingdom at its portals! If Satan's kingdom cannot be entirely eradicated in our actual present world, it can at least be limited, put in chains. So long as it has not been vanquished *from inside* by the Spirit of God, it must be contained by an outside force. Otherwise it would wipe all churches off the face of the earth and attempt to destroy all humanity in man. Nonresistance would be a source of great temptation to the peoples of the world!

Lest they imagine that the kingdom of the beast is all, an end must be put to its blasphemous ugly boasting. Let all nations see that the world is not governed by animal selfishness and advanced technology alone. In human affairs, and especially in the affairs of Russia, let a higher, spiritual force manifest itself, fighting for meaning in the world. Let us remember what we are fighting for, and let this thought multiply our strength tenfold. And let the victory won by our suffering be the forerunner of the great joy that will redeem the boundless sorrows and torments of our existence!

1915

Two Worlds in Old-Russian Icon Painting

I

The discovery of the icon is one of the major and at the same time one of the most paradoxical events in the history of Russian culture. Discovery is the word, for until quite recently everything in the icon was hidden from us—its lines, its colors, and above all the spiritual meaning of this unique art. Yet all of our Russian antiquity lived by that meaning.

We looked at the icon without seeing it. We knew it only as a dark blur in a rich golden setting. Then suddenly all the values were reversed: the setting [*riza*] that covered most of the icon turned out to be a late invention, dating from the end of the sixteenth century, and mainly a product of that pious bad taste that went with the decline of religious and esthetic feeling. At bottom, imprisoning the icon in metal was unconscious iconoclasm, a denial of the painting itself, for it meant that its brushwork and colors were considered unimportant from the esthetic and especially the religious points of view. And the richer the casing, the more clearly it signalled the obtuse lack of insight that could build an impenetrable wall between us and the icon. How would we feel if we saw a Raphael or Botticelli

41

madonna encased in gold and studded with precious stones?
The outrage perpetrated on the great works of old-Russian
icon painting is as much of a crime. Before long this will
become clear to all.

Everything we thought of as the icon is now being
demolished. The dark blurs are being cleaned; here and
there, even the armor of the settings has been breached,
despite violent opposition from our patriotic obscurantists.
At long last, the icon's beauty is revealed to the eye. But
here, too, we usually stop halfway. Too often the icon re-
mains an object of superficial esthetic enjoyment that does
not penetrate to its spiritual meaning. Yet the beauty of its
colors and lines is primarily spiritual. An icon is beautiful
only as the transparent expression of its spiritual content.
Those who see only its outer shell are not much more ad-
vanced than the admirers of gold casings and dark spots.
After all, the sumptuous *rizas* owed their existence to similar
shallow estheticism.

The discovery of the icon is not yet complete. One might
say that it is barely beginning. Once we decipher the lan-
guage of these symbolic images, not understood until now
and still obscure, we shall have to rewrite not only the
history of Russian art but also the history of old-Russian
culture. As with the icon, we saw its shell but did not at all
understand its soul. Today the discovery of the icon enables
us to look deep into the soul of the Russian people, to listen
to its confessions in marvelous works of art. This art re-
veals to us the world view and world perception of the
Russian of the twelfth to seventeenth centuries. From it we
learn how he thought, what he loved, how his conscience
judged and how it dealt with the profound drama of his
life.

Once we have understood these creative and mystical
contemplations, the newly discovered icon will illumine for
us not only the past but also the present and even the
future of Russian life, for it is not some passing stage of
it that these contemplations reflect but its permanent mean-
ing. Yes, for a time it was hidden, even lost to us. But we
are discovering it anew. And discovering it means under-

standing what riches, what potentialities still undisclosed to the world lie secreted in the Russian soul. Let us lay aside arbitrary conjecture about these potentialities and try to read them through their reflections in the icon.

II

The empyrean world of divine glory is not the only subject of old-Russian icons. They also show us the contiguity and interaction of two worlds, two planes of being: on one hand, the eternal peace of the higher regions; on the other, a world of sorrow, sin, chaos, but thirsting for God's peace—a world that seeks but has not yet found God. Like these two worlds, so are two Russias reflected in the icon and counterposed to each other; one is already immersed in eternal calm; in it sounds a ceaseless voice: "All earthly concerns let us now lay aside"; the other *leans* on the church, aspires to it, hopes for its protection and help, and builds its temporary secular edifice around it.

This second Russia is primarily peasant Russia. The church responds to its prayers and hopes, and it has its special patrons among the saints. Everyone knows the close connection with agriculture of the saint of thunder, the prophet Elijah, or of Saint George, whose very name in Greek refers to agriculture, or of the particularly revered saints Flor and Lavr. When Protestants haughtily accuse us of "paganism," they must be thinking of saints of this type, who do seem to have something in common with the pagan gods of thunder, of crops and cattle. But a closer look instantly reveals the shallowness of such a view. The most interesting traits in the images of these saints are precisely those that sharply differentiate them from the anthropomorphic pagan gods.

These traits are, first, the ascetic *unworldliness* of the images; second, their subordination to the *architecture* of the church as a whole; and third, that specific *burning* toward the cross that distinguishes all our church architecture and painting.

Let us begin with Elijah. Novgorod icon painters liked to depict him ascending in a fiery chariot against a bright red, stormy sky. His contact with the terrestrial plane of being is indicated by the Russian shaft bow of his horses headed straight for heaven and by the natural, casual way he hands down his cloak from that stormy sky to his disciple Elisha, who remains on earth. But the difference from the pagan conception is already apparent: *Elijah has no will of his own.* Together with his chariot and lightning, he is swept along in the wake of the flying angel who holds the bridle of his horses. A still more striking difference from the pagan gods can be seen in the *half-length* image of Elijah in the I. S. Ostroukhov collection, where his ascetic mien is especially pronounced. Everything earthly has fallen off, dried off. To be sure, the red background of storm and especially the fire in his eyes testify that he retains his power over thunder and lightning; we expect him to rise and thunder, to hurl down fire or heavenly rain. But his gaunt face tells us that this power comes from a higher, spiritual source. His face bears the stamp of eternal motionless calm. He sends down God's blessing or wrath not from our sky but from an infinitely remote celestial region, infinitely far *above the storm.*

Saint George is another example of a thunder image. His dazzling white galloping steed, the fiery red of his billowing cape, the thrust of the spear as he slays the dragon, all make him a vivid image of God's storm and coruscating lightning. But here, too, we see an ascetic on a spiritualized steed. The steed represents no elemental blind force but a conscious, *seeing* force: this is clear from the soulful expression of its eyes, which do not look ahead but back, at the rider, as though expecting some revelation from him. Moreover, above the storm and wind the artist discerned in the sky a blessing hand that both rider and horse obey.

The pagan conception is equally overcome in the icons of Flor and Lavr. When one sees these saints among gamboling horses of various colors, one gets the impression at first that this jolly picture is something intermediate between an icon and an illustration to a folk-tale, partly be-

cause Flor and Lavr, more than any other saints, retain their Russian—indeed, their peasant—looks. But while ruling over the horses, they themselves are guided by an angel, who also appears in the icons. Still more instructive are their half-length images in the S. P. Riabushinskii collection, where their clear Russian eyes shine with a prayerful fervor that lifts them to infinite heights above this world. Not a shadow of doubt remains that they are no independent wielders of heavenly power but compassionate pleaders for the tiller of the soil, who may have lost or fears to lose his chief asset, his horse. In these icons again we see a harmonious accord between *renunciation of the world* and *prayer for the temporal:* motionless divine calm condescends to human prayer for daily bread.

I have mentioned another trait that distinguishes these saints from pagan gods: their subordination to the architectural unity of the church or, in other words, to the idea of universal communality. Every saint has his own place on the rungs of the ladder that leads up to Christ. Characteristically, in orthodox icon painting this ladder is called *chin* [order of ranks]. Every angel and every saint, including the ones discussed above, belongs to a definite "rank."

All of them fervently aspire toward Christ. This is made especially evident in the icons of the prophet Elijah. In the Transfiguration icon he stands *directly* before the transfigured Christ, bowing to him. And what do we see? Elijah loses his specific aura: the red of his storm pales before the light of Tabor. Bright sunlight floods the entire scene; even the thunderbolt that terrifies the apostles comes not from leaden clouds but from the luminous aura around Christ.[1] The religious significance of Elijah's figure in our icon painting of all periods lies in his subordination to "the prince of life"—and Elijah is no exception. Just as the meaning of orthodox religious architecture lies in that "burning to the cross" that the golden domes eloquently express, so the icons too burn toward the same timeless

[1] Some icons introduce the red color of storm even into Christ's star-shaped aura of Tabor light. These cases will be discussed later.

meaning of human life; everything in the icon points to
it, everything is caught up in that aspiration toward the
supernal reaches where earthly concerns fall away. This
intense ardor lifts toward the cross not the saints alone but
all that is best, most spiritual, in secular Russia, from tsar
to beggar.

Let us look, for example, at that naked innocent, Basil
the Blessed, truly a picture of earthly destitution incarnate.
A remarkable Novgorod icon of the sixtheenth century in
the Ostroukhov collection in Moscow shows this "holy
fool" *[iurodivyi]* against the hopelessly drab background of
a Moscow November sky. His cadaverous body, whittled
down by fast, flagellation, and all kinds of austerities,
harmonizes perfectly with the grey background. As he
prays, a window to another world opens before him. And
lo! he beholds three angels, their wings sparkling with
golden sunrays, at a table full of delicious food: this is
the divine meal of the Holy Trinity as it appeared to
Abraham. Whenever the curtain that hides from us the
supernal world rises for the icon painter, he sees beyond it
this sunny brightness of a flaming, sparkling sky.

The artist's task is harder when the other end of the
human social scale comes into contact with the divine—
when the supplicant is a tsar rather than a beggar. For the
tsar too, as he prays, a window opens, but the event is not
the same as when it opens in a dull grey background:
heavenly beauty must now compete with the *earthly* splendor
of the tsar's raiments.

In the antiquities department of the Rumiantsev Mu-
seum in Moscow there is a seventeenth-century Iaroslavl
icon (No. 336) in which this problem is brilliantly solved.
Prince Michael of Iaroslavl stands before the "Saviour on
Clouds." The rich design of the princely brocade is painted
in strikingly bright colors but at the same time with a kind
of finicky attention to detail, as though to underscore the
vanity of tinsel trappings. We see a perfectly correct, re-
alistic picture of a monarch's robe—and what happens? The
heavy gold is eclipsed and shamed by the noble ethereal
lines of the Saviour's figure sparingly touched with gold.

Every praying, seeking soul finds in heaven the very things it lacks and needs for its salvation. The beggar sees the splendor of a divine meal. The tsar sheds the weight of earthly riches, to take part in the *lightness of the spirit* that hovers above the clouds.

In these ways our old icon painting reflects the live contact with heaven of secular Russia, whether through the image of a peasant, a beggar, or a prince.

III

This holy fervor of Russia is the secret behind the ancient colors of our icons.

We have just seen from several examples how the artists used *color* to separate the two planes of being, the heavenly and the earthly.

We have seen that these colors come in a great variety, from the red of storm to dazzling sunlight to the brilliance of a luminous apparition. But no matter how variegated the colors that separate the two worlds, they are always *celestial* colors, in both the direct and the symbolic sense. They are *the colors of the real, visible sky, but they have acquired conventional symbolic meanings of signs from the otherworldly sky,* that is, heaven.

The great icon painters of our antiquity, as well as the Greek masters with whom this symbolism originated, must have been profound and sensitive observers of the sky in both senses. They saw one sky with their bodily eyes; they contemplated the other with their mind's eye, and it lived in their intimate religious experiences. Their creative art linked them together. The otherworldly sky took on the many hues of the sky we know. Nothing in this process was arbitrary or accidental. Every shade had its place, its reason, its meaning. If we are not always able to see the meaning, this is because *we* have lost it. *We* have lost the key to the understanding of this unique art.

The range of meanings is as infinite as the natural range of colors we see in the sky. First come the blues, of which

the icon painter knows a great many—the dark blue of a starry night, the bright blue of day, and a multitude of light blue, turquoise, even greenish shades that pale toward sundown. We northerners often see these greenish blues after the sun has set. However, only the background is seen as blue; against it unfolds an infinity of the sky's other colors: the glitter of stars, the red of dawn, the reds of nocturnal storms or distant fires; and also the rainbow's many hues; and, finally, the gold of the midday sun.

In old-Russian icons we find all these colors in their symbolic, *otherworldly* meaning. All are used by the artist to divide the empyrean from our terrestrial plane of being. This is the key to the ineffable beauty of the icon's color symbolism.

Apparently its guiding idea is this: the mysticism of icon painting is primarily *solar,* in that word's highest spiritual sense. However beautiful the sky's other colors may be, the gold of the midday sun remains the color of colors and the miracle of miracles. All the others are, so to speak, of subordinate rank, form a hierarchy around it. In its presence, the nocturnal blue disappears; the stars pale, and so does the glow from a fire at night. Even the red of dawn is merely a harbinger of sunrise. Finally, the play of sunrays produces every color of the rainbow, for the sun is the source of all color and all light in the sky and below it.

Such is the hierarchy of colors around the "sun that never sets." Not one color of the rainbow is denied a place in these images of divine glory, but only the solar gold symbolizes the *center* of divine life. All the rest are its environment. Only God, "brighter than the sun," emits this royal light. The surrounding colors express the nature of the glorified celestial and earthly creatures that form his living, miraculously created church. It is as if the icon painter by some mystic intuition had divined the secret of the solar spectrum discovered centuries later; as if he perceived all the hues of the rainbow as multicolored refractions of a single ray of divine life.

In our icon painting this divine gold has a special name,

assist, and is used in a special way. It never looks like *solid* gold; it resembles, rather, an ethereal, airy cobweb of fine rays emitted by God and lighting everything around. When it appears in an icon, God is always suggested as its source. However, in the presence of divine illumination *assist* often glorifies also the part of the environment that has already entered divine life and is seen as touching it very closely. For instance, it covers the throne and the brilliant mantle of Sophia the Divine Wisdom, and the mantle of the Virgin as she ascends to heaven. Angel wings and the tops of paradisial trees are often touched with it. In some icons, *assist* appears on the pointed domes of churches, never covering them but, rather, making them glitter with sparks and rays. The ethereal quality of these rays gives the domes an air of live, glowing, moving light. The garments of Christ in glory glitter with sparks; the throne and mantle of Sophia glow like fire; church domes burn to the sky. This sparkle and fire separate the otherworldly glory from the unglorious, the here-below. Our world merely *aspires* to the heights, *imitates a flame,* but becomes truly illumined by it only at the utmost heights that only the peaks of church life can attain. The trembling ethereal gold gives these peaks, too, a look of otherworldly brilliance.

In general the otherworldly colors were used with remarkable tact, especially by our Novgorod painters. *Assist* does not appear in the icons where Christ's *humanity* is stressed, where he "took upon him the form of a servant." But as soon as the artist sees Christ in glory, or wants to convey his imminent glorification, he introduces *assist.*[2] Christ as infant often glows with it when the artist needs to emphasize the *eternal* nature of the child. This fine gold covers the garments of Christ in icons of the Transfiguration, the Resurrection, and the Ascension. He shines with the same specific divine brilliance when he is shown leading human souls out of hell, or in paradise with the thief. The strongest impact is achieved by the use of *assist*

[2]This method of using *assist* can be clearly traced in the icon *Shestodnev* by Dionysios, belonging to I. S. Ostroukhov.

where the artist needs to contrast the two worlds, put a distance between the divine and the earthly. We can see this, for instance, in very old icons of the Dormition. One glance at the best of them makes it clear that the Virgin reclining on her deathbed, in her *dark* clothes, with all the familiars surrounding her, remains corporeally on *this* plane of being, the one we can touch and can see with our earthly eyes. But the figure of Christ in light raiment, standing behind the bed with the Virgin's soul in the guise of an infant in his arms, is clearly an otherworldly vision. The whole figure shines and sparkles, separated from the intentionally heavy colors of the earthly plane by the ethereal weightlessness of its *assist*-covered lines. The contrast is particularly well brought out in two sixteenth-century icons in the Moscow collections of A. V. Morozov and I. S. Ostroukhov.

Some icons (in the Ostroukhov collection) show in addition the Virgin already glorified, high in the sky, in that same golden brilliance, among angels also shining with *assist.*

In other icons of the Dormition, other colors of the celestial range are used to achieve the effect of separation of the two planes. Christ standing behind the deathbed is separated from the Virgin not only by *assist* but also by a special coloration of the celestial sphere surrounding him. Sometimes a single sphere forms around him a dark blue oval in which cherubim are seen. All these cherubim seem to drown in the blueness—except one, flaming red at the apex of the oval above the Saviour's head. Sometimes, however—as in a remarkable Novgorod icon of the six-teenth century at the Alexander III Museum in Petrograd—the oval contains many celestial spheres, one above the other, distinguished from one another by a multitude of shadings of light blue, including some incredible greenish-turquoise tints. The impression of something literally "out of this world" is overwhelming. For a long time I worried over the question of where the artist could have observed such colors in nature—until I saw them myself, after sun-down, in the northern Petrograd sky.

These blues animated by winged bodiless angel heads
are a relatively simple mystery, compared with the bright
celestial red [*purpur*] that makes the Novgorod icons so
beautiful. Here the mystery is much more complex, and
perhaps much deeper, compounded as it is by the extra-
ordinary variety of reds. As we have seen, the artist knows
the red of the storm spiritualized by the figure of Elijah
hurling down thunderbolts; he knows the red skyglow
above a fire at night and uses it to light the abysmal dark-
ness of hell; he places a flaming cherub at the gates of
paradise. In ancient Novgorod icons of the Last Judgment
we even see a whole fiery barrier of cherubim directly *under*
the image of the future world and *above* the heads of the
seated apostles. These images of heavenly fire are still
fairly easy to interpret. The question becomes much harder
and more involved when we consider the mystical implica-
tions of the red of Saint Sophia the Divine Wisdom.

Why did our icon painters use this bright paint for the
face, hands, wings, and often the garment, of the eternal
Wisdom that has created the world? No one so far has
given a satisfactory answer. It is often said that Sophia's
red represents a flame, but this does not really explain any-
thing. As we have seen, there are many kinds, and there-
fore many meanings, of otherworldly flame, from the sunny
radiance of *assist* to the sinister glow above the fires of
hell. Which specific flame is meant here? What is the
fire with which Sophia flames, and how does it differ from
other mystic revelations painted in the same red color?

The answer can be found only in the solar mysticism of
colors described above, through which the otherworldly
mysteries are symbolically expressed. A study of the best
Novgorod images of Sophia leaves no doubt about this.
Whether we take the outstandingly beautiful silk-embroidered
fifteenth-century Sophia given by Count A. Olsufiev to the
Moscow Historical Museum, or the no less beautiful Nov-
gorod Sophia at the Alexander III Museum in Petrograd,
not to mention numerous red Sophias of lesser artistic merit,
they all have one thing in common: Sophia always appears
against the dark blue background of a starry night sky.

This contact with the dark of night lends the heavenly red its surpassing beauty—and explains its symbolic meaning. We hear in our churches, "In wisdom hast thou made them all" [Psalm 104:24]. This means that the Wisdom embodied in Sophia is the design of God that preceded creation and called all celestial and earthly creatures forth from non-being into being, *out of the darkness of night.* That is why Sophia appears against a background of night. And this dark background makes her brilliant celestial red absolutely necessary. It is the red of God's dawn emerging from the night of non-being; it is the eternal sun rising over all living things. Sophia is what precedes the *days* of creation.

It is hard to say how active a role conscious reflection played in the choice of paint. I rather think that Sophia's red was a sudden instinctive inspiration suggested by the artist's mystical *superconscious.* In the end, it makes little difference. The painter's deep knowledge and love of the sky—in both senses of the word—told him that when the sun rises out of darkness, or comes into contact with darkness, it inevitably turns red. He saw and felt this every day, he was used to it. Does it matter whether he consciously painted dawn, or whether unconscious reminiscence influenced his art? In either case, Sophia for him took on the color of dawn. He *saw* the dawn of the world, and he painted what he saw.[3]

Incidentally, he was not the first to behold at dawn a

[3]*Cf.* V. S. Soloviev's verses about "Sophia":
 And in the brilliance of celestial red,
 Eyes full of azure fire,
 You looked like the first rays
 Of the universal creative day.
Evidently the famous Novgorod image of Sophia illustrates the first lines of the Gospel According to John. The book at the top of the icon represents the line "In the beginning was the Word"; the image of Christ immediately under it obviously stands for "And the Word was God." The icon directly relates Sophia to the Word "by whom all things were made." The dark night suggests the words "And the light shineth in darkness; and the darkness comprehended it not." This explains too the presence in the icon of the Virgin and John the Baptist, the two witnesses for the Word.

miraculous vision with flaming face and fingers. Everyone knows Homer's winged verse about "rosy-fingered Eos" rising out of the dark.

The difference between the icon painter's Orthodox-Christian and Homer's pagan perception of the world is that for Homer the rosy fingers meant the earthly dawn, not the dawn in the otherworldly sky. Red in both cases is the morning light, but the principle animating it is entirely different.

One more detail in these icons confirms the solar nature of "Sophia." I have already mentioned the fine cobweb of *assist* that covers her. Clearly her fiery visage appears to the artist in the brilliance of sunrays.

Let us compare this image with that of Christ enthroned in glory. Obviously it would be sacrilegious to paint a red Christ! Why is it that the color that would be so wrong for Christ is fitting and beautiful for Sophia? Because in the solar sphere of the icon's mysticism only one color befits the Lord, the one that stands highest in the hierarchy of colors, the royal light of eternal day. For Sophia, on the other hand, in view of her subordinate place in the heavenly hierarchy, the suitable color is red since it heralds the sun's supreme revelation.

This is not the only instance in Russian icon painting where red marks the contact of sunlight with darkness. The same can be observed in an icon in the Ostroukhov collection, a sixteenth-century "Transfiguration" from Ustiug. Usually the Transfiguration is painted against a daylight background, but in this icon the ground is a starry sky; the light of Tabor wakes the apostles sleeping in the dark.[4] In this night picture the colors are different from those used in *day* icons of the Transfiguration. Novgorod icons always depict the light of Tabor in the shape of a star around Christ. At its center, Christ is always bathed in the golden light of *assist,* in accordance with the Gospel's words, "And his face did shine as the sun" [Mat. 17:2], but the edges

[4]Evidently the artist had in mind Luke 9:32, which speaks of the awakening of the apostles "heavy with sleep."

of the star are usually filled with other colors of the sky—dark and light blue, greenish, and orange. In the Ostroukhov icon, the light of Tabor turns red and not blue as it touches the surrounding darkness. This expresses a bold and profound conception of the artist's: In the symbolic darkness of night that envelops the universe, the lightning that wakes the apostles announces the dawn of God's day and thus puts an end to the heavy sleep of sin.

This dawn differs, however, from "Sophia's" in one notable way: the red that colors her face, hands, and wings expresses her very essence; in the Transfiguration icon, the red appears only in the star around Christ, and then only at its edges: it is but one of the background colors of the Transfiguration.

To conclude this discussion, it remains to be said that the icon painters were also fully aware of the most beautiful of all the manifestations of solar light, the rainbow. I have mentioned (p. 34 of this book) that in the Novgorod icons of the Virgin the creatures united around her in Christ form a many-hued rainbow. A remarkable treatment of this rainbow, showing deep insight into its mystical essence, can be found in the icons "The Virgin of the Burning Bush," in particular the fifteenth-century Pskov icon owned by S. P. Riabushinskii. Here a single ray of God's sun is refracted into a multicolored hierarchy of angels gathered around the Virgin and ruling the earthly elements through her. In this aura every spirit has its own distinct color; but the single ray associated with the Mother of God, the flame that shines through her, unites in *her* the entire spiritual range of the heavenly spectrum: the entire many-colored angelic and human world burns with that flame. Thus the Burning Bush stands for the ideal of "enlightened," glorified creatures—a world that has come to embrace the Divine Word and burns in its fire without being consumed.

IV

From the old-Russian icon's solar mysticism we shall

now pass to its psychology, to the human feelings and moods associated with the experience of receiving the sun's revelation.

The icon deals with an extremely complex and varied gamut of emotions. The sunny lyrical motif of joy inevitably interweaves with that of the greatest sorrow on earth, the drama of two worlds colliding with each other. The happy lyrical upswing, the joyous mood of vernal glad tidings is what strikes us first in the paintings on ancient royal gates. The four evangelists appear every time, and so does the Annunciation, representing the joy they proclaim. These images are treated very differently in various icons, but they always in one way or another reflect the Russian popular idea of the festive day when all creation rejoices together with man—the spring day when the birds arrive. Annunciation is a holiday when "even birds don't build nests," according to popular belief.

Sometimes this mood is conveyed by a rainbow of gay colors on gold—the joyous play of many-hued angel wings around the Virgin and the evangelists. I. S. Ostroukhov's royal gates from Novgorod are a fine example of this treatment of the great spring holiday. But the same collection also contains another, no less beautiful and profound representation of this warm and light-filled day when the sun turns toward the earth.

I have in mind the six small icons of the Annunciation and the evangelists taken from royal gates (Stroganov school, sixteenth century). There is no rainbow here; everything is flooded with bright midday light. Such a dazzling noon can be seen only in the south, and this poses an interesting riddle: From what southern lands could the Russion icon painter have brought to our melancholy north these truly *glad tidings* of a joyous light never seen or heard of in our part of the world?

The evangelists' figures on royal gates express the feelings evoked in saintly souls by this revelation of light. Here we must note one of the most arresting traits of Russian icon painting.

One would think that the rainbow of light and the

midday radiance surrounding the evangelists were something
for the *eyes* to feast on. But take a good look at the
evangelists' postures: they convey the mood of people who
are looking but do not see—because they are totally en-
grossed in *listening* and in *writing down what they hear.*
Look at their curved spines as they write: this is the posture
of submissive agents of God's will, passive human instru-
ments of the revelation. The images of John, the most
vivid and most mystical of all and therefore the most typical
of the *Russian* religious perception of the world, have an
additional detail that underscores this impression of passivity.

Although John does not write but dictates to his disciple
Prochorus, his back is bent in the same way: it expresses
total *surrender* to the revelation. And this dictating teacher
of the Word in turn has an obedient instrument in his
disciple, whose entire body expresses boundless, *blind* sub-
missiveness. He is, so to speak, the apostle's human echo,
repeating him and unconsciously duplicating, sometimes
even exaggerating, the very curve of his back.

Submissiveness is not the only psychological response of
a human being to the experience of divine revelation. The
highest manifestation of this state of mind is undoubtedly
the *inner hearing that can perceive the unspoken.* This
ability is shown in our icons in different ways: sometimes
by the turn of the evangelist's head toward an invisible
light or spirit, as he momentarily stops his work—a half-
turn, rather, as if he turned toward the light not with his
eyes but with his *hearing;* sometimes not even by a turn
but by the pose of a man entirely immersed in himself,
listening to some inner voice of unknown provenance that
cannot be located in space. But this listening is always
depicted in icons as a turn toward something *invisible.* This
is what gives the evangelists' eyes their *otherworldly* expres-
sion. They do not see their earthly surroundings.

In combination with the apostles' figures, the very light
that lights them acquires a singular symbolic meaning. Be-
cause they perceive it not with their eyes but with their
inner hearing, the radiant midday light is spiritualized: it
becomes the otherworldly *resounding light.* Solar mysticism

is transformed into mysticism of the light-bearing Word. The Gospel According to John describes the Word for good reason as the *light* that shineth in darkness. Our icon painting draws all its lyricism, and all its drama, from this use of the world's beautiful colors to express the otherworldly meaning of the Word. All there is in man of *light-filled* joy of life rises to meet the rising sun of the Gospel. In its rays human love itself becomes winged and is blessed from above. The icon painter not only knows this pure upsurge of human love, he celebrates it in joyous hymns. They are not the nightingale's nocturnal songs but the sunny hymn of the skylark as it rises into the deep blue heights.

On the threshold of the Gospel's revelation, at the very door of the New Testament, stands the holy but nonetheless purely human love of Joachim and Anna that the icons celebrate. In the icons of the Virgin and her life we find around the main icon a number of little pictures tracing the story of that love. One of the best is the sixteenth-century "Presentation in the Temple with the Life of the Virgin" in A. V. Morozov's collection in Moscow. In the first picture, the high priest banishes Joachim and Anna from the temple for their barrenness. In the next two, they grieve separately—he in a desert, she in a woods; nesting birds remind her of the cause of her grief. But the lonely suffering is relieved by the appearance of a consoling angel with glad tidings.

Then the tidings are fulfilled in the conception of Mary. Our icon painting, always profoundly symbolic when it deals with the otherworldly, achieves an astonishing *sacred realism* when it depicts the joy that comes true in this earthly love. In the foreground we see Joachim and Anna kissing; some icons show *behind them* a double bed; above the bed, a church consecrates this connubial joy with its blessing. The icon painter touchingly stresses the dovelike quality of that love. Two ancient icons of the Virgin's Nativity in Pskov churches show Joachim and Anna caressing the newborn child; white doves come flying to look at the happy family. Domestic fowl—a goose and a duck—also

appear in this homey picture, making it a cozy well-rounded idyll.

But no matter how great the beauty and light of an earthly love, it does not lead to the highest solar revelation. Descent inevitably follows ascent. That spring skylark may rise high into the blue sky but it never reaches the sun; after a dizzy rise it returns to earth—to pick grains and produce offspring for new flights that will again fail to reach their goal. To free the earthly world from captivity and lift it to heaven, the chain of flights and falls must be broken. Earthly love is called upon to make the greatest of all sacrifices—*it must sacrifice itself.* That is why in our icons this idyll of earthly happiness does not transgress the line between the Old and the New Testaments. It is, so to say, a borderline phenomenon—a lyrical preface to the New Testament drama.

The very rise of earthly love to meet the otherworldly revelation inevitably leads to its tragic collision with another, higher love—for the higher love, in its own way, is as exclusive as earthly love: it too wants to possess the whole person.

The icon painter discerns the inception of this drama at the very beginning of the Gospel story, right after the Annunciation. The drama takes place in the soul of Joseph, Mary's husband.

Centuries have indifferently passed by this old man. He was barely noticed: attention centered on the absorbing miracle of the Virgin Birth. Only Russian icon painting, in the wake of very imperfect Greek models, looked with penetrating insight into his soul—and made an important discovery.

The art that had sung the happiness of Joachim and Anna instinctively sensed that the soul of the righteous Joseph harbored the same human, all too human, understanding of love and bliss, reinforced by the Old Testament view of sterility as a blot on honor. Such a view could not possibly encompass the mystery of a birth "from the Holy Ghost and the Virgin Mary"; for the Old Testament mind this was a *catastrophe,* an unimaginable cosmic and moral

revolution. How could the simple human soul of Joseph cope with a trial of such magnitude? In a country where barrenness was a reason for banishment from the temple, a voice from heaven tells him to guard the virginity of his betrothed wife! The Russian icon painter—who sometimes put both motifs on one panel, together with a picture of the events—understood perfectly what a storm of emotions this clash between the New and the Old Testaments must have stirred up. Old Novgorod and Pskov paintings of the Virgin's life show Joseph *alone* with Mary after the Annunciation. In a remarkable fresco at the Therapont monastery this scene is actually called "Having a storm inside."

The "storm inside" is presented in a still finer way in Novgorod and Pskov icons of the Nativity. In the bottom part of the icon, immediately below the reclining Virgin and the manger, Joseph is being tempted by Satan in the guise of a shepherd. The shepherd is pointing to a crooked knotty stick. Joseph is either sunk in deep reflection or listens to the tempter with an expression of doubt, sometimes of despair and horror, almost of madness.[5]

The temptation boils down to the simple "peasant" argument: "Just as no leaves can grow from this dry stick, an old man like you cannot produce offspring." These are Satan's apocryphal words to Joseph. Of course the icon painter knows of the angel's words, "Fear not to take unto thee Mary thy wife," but his common sense tells him that even a soul that has heard the divine message is not impervious to temptation. The simple argument casting doubt on the birth of Christ sounds the more persuasive the simpler the tempter looks. Old-Russian icon painting stresses this with great restraint, making Satan appear as a shepherd. Nothing save the vile curve of his spine betrays the satanic nature of the insinuation. Among the many icons on this subject that I have seen, I know of only one, in a cupola of the Moscow cathedral of the Annunciation, where the "shepherd" has barely noticeable little horns.

[5]The tragedy is rendered with particular skill and clarity in the 16th-century Novgorod Nativity belonging to I. S. Ostroukhov.

What is most surprising here, apart from deep insight
into the human soul, is the broad generalization, the winged
thought rising to timeless heights, spanning centuries! In
Joseph our icon painters sensed more than a personal drama—
they sensed the universal human drama, repeated through-
out the ages and bound to go on repeating itself until the
tragic collision of the two worlds is resolved, for this drama
is *always the same*. Six hundred years have gone by since
the best Novgorod icons of the Nativity were painted, but
there is no essential change in the nature of the tempta-
tion. The shepherd's argument underlies modern rationalistic
criticism as it keeps repeating, "There is no other world
than the earthly world we can see, consequently there is no
way to be born except by natural birth from corporeal
parents." The "form of the servant" concealing God re-
mains an unsolved mystery, and the incursion of the other
world into ours provokes the same storm and rebellion.
Monks experience this storm with especial vehemence, for
every monk renounces all earthly love for the sake of
Christ. Is this why the icon painters understood it so well?

Be that as it may, our icons reflect the struggle of two
worlds and two perceptions of the world that fills the his-
tory of mankind. On one hand, we have the *flat* perception
that reduces everything to the *earthly* plane; on the opposite
side, the mystical perception, which sees in the world and
above it a great multitude of spheres, a great variety of
planes of being—and knows it is possible to pass from
plane to plane.

Perhaps the most touching, the most attractive feature
of the icons that express the latter view is the loving
Christian approach to the unhappy soul that lacks the
strength to rise above the earthly plane. In the best Nov-
gorod icons of the Nativity the Virgin is not looking at
the Infant in the manger: her deeply compassionate gaze
rests on Joseph and his tempter.

In the sacrifice demanded of Joseph there is a fore-
taste of the perfect sacrifice: we can already feel man's
incipient burning toward the cross, the nailing of all his
thoughts to the cross. This foretaste of the suffering bound

up with the birth of Christ is expressed in icons through
another figure, also very significant and profound—that of
Saint Simeon. A superficial understanding of the Christian
revelation interprets his "now letteth thou thy servant de-
part in peace" as merely an expression of boundless joy at
having seen the closeness of salvation. The icon painter,
having truly received Christ into his soul, looks deeper:
he knows what a price in suffering must have been paid
for the joy of salvation if it mingles with a man's joy that
his earthly end is near; he senses the depth of sorrow that
makes this end a welcome release. And he understands that
Simeon's "now letteth thou" resolves the profound suf-
fering that sounds in his words to Mary: "Yea, a sword
shall pierce through thine own soul also" [Luke 2:35]. That
is why Simeon's face in the best Novgorod icons bears the
imprint of superhuman inexpressible sorrow.[6]

Simeon *foresees the cross*. Therefore the sorrowful fig-
ures at the foot of the cross in other icons, whatever their
merits, can hardly add new mystical revelations or indica-
tions. Novgorod has given us great, talented icons of the
Deposition and the Entombment [mentioned on p. 22 of
this book], but the sorrow in the faces of the Virgin and
the apostles in these icons is essentially the same that
Simeon's dolorous face foresees. It is the sorrow that burns
to the cross, inflames human hearts, and thus prepares
them for receiving the sun's revelation. In the light of that
flame, God's judgment of the world is revealed to the icon
painter. From his icons of the Last Judgment we shall see
how he understood this revelation—and how he himself
judged the world.

V

In its representations of the Last Judgment, Novgorod
icon painting of the fifteenth and sixteenth centuries gives
us a glimpse into the deepest recesses of "Holy Russia's"

[6]For instance, the Simeon in I. S. Ostroukhov's collection.

spiritual life, that is, into the *judgment of her conscience.*
These colorful paintings are doubly valuable because the
icon painter's human conscience sought to divine God's
judgment about humanity as a whole, the world as a
whole, rather than about any specific cases. The images in
which he presents the Last Judgment surpass in depth and
power the most eloquent human words.

From the outset, the icon painter faced a moral problem
that cannot be resolved within the framework of earthly
life. By its very nature, our world is neither heaven nor
hell but a mixture of both, and the battlefield on which
they fight each other. Accordingly, most people are neither
saints nor monsters but the mixed, ordinary type described
by the folk saying as "no candle to God but no poker for
the devil." How will God judge them when the time comes
for the final, irrevocable separation of grain from chaff?

The icon painter does not really answer this question.
Rather, he poses it in an extremely broad and daring way,
which attests his deep understanding of life and his insight
into the human soul.

A. V. Morozov's collection in Moscow has two Novgorod
icons of the Last Judgment, one of the fifteenth century
and the other of the sixteenth. In the lower half of each
we see a kind of frontier post between the right and the
left, the side of paradise and the side of hell. A human
figure is tied to the post. Whom does it represent? Any
number of guesses are possible. Is it the type of "nice
fellow," not good enough for paradise because he never
denied himself anything, and not bad enough for hell
because he was kind? Or the type that is neither hot nor
cold but *lukewarm*—the decent man of respectable conduct
but lacking in Christian charity? These guesses are more
or less likely, but one thing is sure: The figure represents
the prevalent, average, borderline type, equally far removed
from the godly and the satanic. Not knowing what to do
with him, how to judge him, the icon painter left him tied
to the post in the middle. On both sides of him other souls
are being consigned to the realm they deserve.

On the left are the flames of hell, a world on fire.

On the right, a procession sets out for paradise. This is rendered in the manner characteristic of our best icons: we see a *movement of souls* rather than of bodies, and it is expressed through the eyes, which gaze ahead *toward the goal.* The goal is marked by a bright red figure that at first glance looks like a pillar of fire. But the joined wings and the flaming eyes looking out between them leave no doubt that this is a fiery cherub guarding the gates of paradise. Beyond this line, the procession touches Abraham's bosom, personified by three angels seated at a table, as they appeared to Abraham. Here the final transfiguration of the righteous souls takes place. For the icon painter it is like a chrysalid's transformation into a butterfly. Having touched Abraham's bosom, the righteous souls receive wings. Haloed in gold, they rise like butterflies in graceful flight toward the apostles judging the world. There, *above the apostles' heads,* is the last barrier—a garland of red cherubim. And above these, at the very top, glows the sunny vision of the new heaven and new earth. The flight of the righteous to paradise is balanced on the left side of the icon by the headlong fall of dark satanic figures into the bottomless pit of hell.

This, too, is treated with profound mystical insight into the human soul. The falling figures seem to be joined into an unbroken chain from top to bottom, to the lowest reaches of hell. The curves of the chain produce an astonishing esthetic effect, but for the icon painter this isn't the point: he seeks to understand God's judgment. He feels that the demons are not isolated in their fall: all human sins hang together, every vice and every sin brings innumerable others in its wake. And all sinful souls are linked by the common temptation with which they contaminate one another. We see an implacable *chain of sin* fettering them in eternal slavery, in contrast to the *free* flight of the righteous souls.

Between the two extremes there writhes a huge annulated serpent, and each of its countless rings is full of dark figures personifying the endless continuity of sins in a world sunk in evil. These are the sins that have not yet been judged, are not yet consigned to hell's dark domain.

They still belong in that middle region where tares and wheat grow together. Just as earthly righteousness is merely an imperfect beginning of the kingdom of truth, so these sins represent hell *incomplete, hell in the making.*

From these visions of the Last Judgment we can clearly see how the two extremes of life relate to each other in the icon painter's mind. His is a world perception heightened in its very essence. On one side, there is a live, effective feeling of hell *in the making* on earth, and a clear view of the abyss into which descends the chain of sins that begins here on earth; on the other side, there is a bright concrete vision of heaven, the goal of the luminous spiritual ascent and flight.

The two parts of this intensified perception of the world are indivisibly related. The icon painter perceives the bottomless abomination of hell that lies hidden under the earthly cover, and this perception lights in his soul the burning to the cross, the redeeming sorrow that is resolved in the cry, "Now letteth thou thy servant depart in peace." On the other hand, it is this burning, this high spiritual flight, that gives him the courage to look down into hell and take the measure of the dark deep pit below.

VI

As we contemplate the revelation of two worlds in old-Russian icon painting, we experience a mixed feeling of great joy coupled with deep pain. We begin to understand what we had in our icon painting, and this makes us realize what we have lost. The thought that these deathless memorials of spiritual greatness belong to our distant past suggests something very alarming about our present.

The loss becomes evident as soon as we compare the old and the new trends in church architecture, for it is the ancient architecture that most clearly reflects the life style of holy Russia. The eye rejoices at the old churches of Novgorod, of Pskov, of the Moscow Kremlin. Every line

of their simple and noble forms reminds us of the holy fire that once burned in Russian souls.

We feel that in ancient Russia not only the church domes assumed the flame-like style but everything that lived a spiritual life—the entire church and all the secular elements that were united in it, from prince to peasant.

In the ancient church not only the main domes but also the subsidiary ones above the outer walls, and the climbing exterior ornaments, often have the flame-like, pointed form of a bulb. Sometimes all these parts combine into a pyramidal bulbous shape. In the general elan toward the cross *everything seeks the flame,* imitates its form, narrows to a peak in its gradual ascent. But only when it reaches the real point of contact of the two worlds—that is, at the foot of the cross—does this ardent aspiration burst into a bright flame and unite with the celestial gold. In this union lies the mystery of the gold about which I have already spoken at length in discussing the revelations of icon paintings. The ancient church architecture expresses the same spirit as the paintings.[7]

Achieving this burst of flame is what "Holy Russia" exists for. Her glowing church domes are her own spiritual image, prefiguring the divine image that is *bound* to appear in her.

Present-day Russia is divided from this image by the abyss of her spiritual decline. We can measure it by simply taking a walk in Moscow, outside the Kremlin, and studying the architecture of the "forty times forty" churches that used to be Moscow's glory. We shall see some classical monuments to mindlessness, that is, meaninglessness. Most of the domes betray the fact that the bulb's revelation has been lost, that its meaning is not at all understood: one does not sense the presence of the inner cupola beneath the dome. When the building itself lacks the fiery elan, the flame-like domes do not organically flow from the

[7]Some of the churches depicted in icons are marvelous examples of church architecture. One of the best is in the remarkable 15th-century Novgorod icon *O tebe raduetsia* at the Alexander III Museum in Petrograd.

idea of the church as its inevitable completion but become meaningless ornaments. With their long stems they resemble chimneys *mechanically* attached to the church roof. And this is one of the lesser distortions. Worse things can be found in Moscow. Uninspired builders, failing to understand the meaning of church architecture, attach extraneous decorations instead of carrying out the *idea* of the church. All they think of is how to embellish the building in some way, any way. This often results in monstrous inventions. There are belfries topped with a gilt Empire column that would make a fairly handsome stand for a livingroom clock. I know a church that boasts a gazebo with Empire columns on top of the dome, a bowl atop the gazebo, something like a turnip on top of the bowl, then a spire rising from the turnip, then a sphere, and finally a cross. Every inhabitant of Moscow knows the church topped by a crown instead of a bulb—because the Empress Elizabeth was crowned in it. One of the largest monuments to costly senselessness is the church of the Saviour. It resembles a huge samovar around which patriarchal Moscow has cozily foregathered.

Essentially, these monuments to modernity express the mood that has caused the ruin of a great religious art. What we have here is not merely poor taste but something much bigger: deep spiritual deterioration. A builder of churches brings to the foot of the cross whatever fills his own soul. The ancient builder, like the ancient icon painter, found here a ray of the sun's revelation; the modern builders lift to the cross their own memories of the court or of commonplace daily life. The old builders carried in their souls the fire of the Burning Bush; the new ones carry a crown, a samovar, or a turnip.

The appalling resemblance of the new domes to household utensils reflects the dreary spiritual *meshchanstvo* [genteel petty-bourgeois vulgarity] that has engulfed the modern world. Because of it, no true meeting of two worlds occurs in our church architecture. Everything in it speaks only of the temporal, expresses an utterly flat, pedestrian view of the world. The forgotten icon, the decline in the

art of icon painting need no further explanation. The icon was encased in a gold armor and its colors were confused with a film of smoke by the same spiritual mediocrity that has damped the flame of our church domes.

Again it is our old icon painters who have best defined this trait. They have perfectly rendered its essence in the figure of the man standing between heaven and hell and not qualifying for admission to either because he has no understanding of either heaven or hell.

He is unable to see anything in depth because he represents the *humdrum middle.* This middle has come to predominate in the world—not in Russia alone but *everywhere.* Everywhere creative religious thought and feeling have run dry. The West has unlearned building in the Gothic style as we have unlearned building in the bulbous style. Painters like Fra Beato or Duerer have disappeared for much the same reason that explains the decline in Russian icon painting. The reason is everywhere the same. The impoverishment of spiritual life is rooted in the complacency that results from increased material prosperity. The better a man's earthly surroundings, the less does he aspire to the otherworldly, and the stronger is his bent for undisturbed, comfortable *neutrality* between good and evil.

There are periods in history, however, when the struggle between good and evil reaches extreme intensity, and neutrality becomes impossible. At such times two infinities open at once—*above* and *below* the daily middle—and man is forced to choose between upward flight and a fall into a bottomless pit.

Such times come when the evil inherent in man is not held in check by peaceful, civilized forms of community life and therefore manifests itself in gigantic dimensions and forms. Then the armies of heaven gird for battle; in thunder and lightning, humanity receives their high revelations. This happens when a red glow of blood covers the sky, in times of war, great upheavals, and all kinds of internal horrors. Man's well-being collapses, and spiritual complacency disappears with it. Complacency was impossible when monsters like Ivan the Terrible or Caesar Borgia

enjoyed power and roamed at will. In those days Basil the Blessed could see heaven open before him, and Fra Beato's genius could paint glowing visions of the crucified heart. Both the Russian icon painter and the Italian artist were granted these visions because they had seen Satan in the flesh. Both had known the uttermost suffering, and both had that clear perception of hell's presence on earth that has always been, and still is, an impetus for spiritual ascent, spiritual striving.

This explains the flowering of our icon painting in Novgorod, Pskov, and Moscow. For the Russian painters who had lived through the horrors of ceaseless war, who had seen everything around them laid waste again and again, who had daily observed rampaging human monsters unchecked by laws—for these icon painters hell was a tangible reality, not merely a matter of belief. Therefore their religious feeling was neither cold nor lukewarm but *fiery*. Their heaven took on the bright colors of *visible* reality. This vision, born in the midst of extreme trials, began to fade only when safety and comfort returned to the world, and with them came spiritual sleep. Hell and heaven both disappeared from view, along with all else that belongs to the other world. During the centuries that separate us from our Novgorod icon painting, the world has seen great surges of *human* creativity—among them, the flowering of poetry in our country and in the West. But no matter how lofty these flights, they do not reach heaven, nor do they open the depths of hell. Therefore human creativity, so long as it is *only* human, cannot entirely over-come complacency. German poetry is full of complaints about Philistinism, for good reason: it is possible to sleep even with a copy of *Faust* in one's hand. To bring awakening, a thunderclap is needed.

Now, when the sleep has been thoroughly disturbed, there is hope that universal stagnation is coming to an end. Hell is laid bare again, and that is not all: the fatal connection of hell with our spiritual complacency is also becoming evident. *Meshchanstvo* is not as neutral as it appears at first glance. Bloody crimes and wars are hatched

in its bosom, nations fly at each other's throats because of it. It has lit the present conflagration: the war began with a quarrel over a juicy morsel, "a place in the sun."

This quarrel was not the worst thing to be born from today's petty, self-seeking mentality. Comfort breeds *traitors.* The sale of one's soul and one's country for thirty shekels, the compromises with Satan for the sake of profit, the *worship* of Satan, who seeks to infiltrate the holy of holies of our churches—in the end, all this comes from the vulgar ideal of well-fed comfort. Now this ideal has been exposed, and we, like the icon painters of old, can see the dark chain that descends from the surface of our lives into the bottomless total dark.

Next to this, at the other end of the picture, there already begins the regeneration of souls that have had enough of our wormlike form of existence. In the spiritual upsurge that followed the outbreak of the war, we have seen the flight of winged souls, we have seen people offering the greatest of sacrifices, giving up for their brothers their worldly possessions, their life, and even their souls. If by now some are weakening, others have been strengthened for high deeds.

Possibly our present experiences are only the first symptoms of a sickness; possibly they are merely the first manifestations of a long turbulent period in world history that will bring horrors unseen and unheard of before. But let us remember: Great spiritual uplift and creative thought, especially religious thought, are always forged in the suffering of peoples and in great trials. Perhaps our sufferings too are the forerunners of something inexpressibly great that is to be born into the world. Then we must firmly keep in mind that our spiritual birth pangs will be transformed into joy.

In the midst of these torments the discovery of the icon comes at the right time. We need these glad tidings of spring and the red of dawn that heralds the joy of sunrise. So as not to fall into despondency but fight to the end, we need to carry before us the banner on which the beauty of heaven is joined with the sunny visage of glorified,

holy Russia. May the benediction inherited from our distant forebears be an appeal to creative work. May it augur a new great period in our history.

1916

Russia and Her Icons

In the vestry of the Troitsko-Sergiev monastery there is a deeply moving image of Saint Sergius, embroidered in silk on a pall for his sarcophagus. It was given to the monastery by the Grand Duke Vasilii, son of Dmitrii Donskoi, probably in 1423 or 1424. The most gripping thing about this image is the sorrow it portrays—not an individual, personal sorrow but profound grief for all of the Russian land despoiled, abased, and rent by the Tatar invasion.

As we look at the image, we begin to feel that it expresses something even deeper than grief: a surge of prayer into which the grief is transmuted. And we leave consoled, sure that the holy sorrow has reached heaven and obtained its blessing for sinful, suffering Russia.

I know of no other icon that so cogently expresses the thoughts, feelings, and prayers of a great people and a great historical epoch. It is no accident that the donor was a son of Dmitrii Donskoi: one can sense that the image was embroidered with love by one or more of the pious fifteenth-century Russian women who may have known Saint Sergius and certainly had experienced the impact of his holy deeds that saved Russia.

It would be hard to find another monument of our antiquity as eloquent of the spiritual strength that created

71

Russian icon painting. It is the strength that informed the efforts of the greatest Russian saints—Sergius of Radonezh, Cyril of Belozersk, Stephen of Perm, and Metropolitan Alexis—and wrought the spiritual and national revival of the fourteenth and fifteenth centuries.

Russian icon painting came to flower when Russia had united around Saint Sergius's monastery and began to grow from the ruins. It is not surprising that these events coincided in time. The three great facts of Russian life—the saints' spiritual efforts, the secular ordering of Orthodox Russia, and the achievements of religious art—are bound together by the close ties of which Saint Sergius's silk-embroidered image speaks to us. And not only this image. The icons of the fourteenth and fifteenth centuries in general give us an astonishingly true and complete picture of Russia's spiritual life at the time. In those days of live faith, the prayer "We have no other recourse, no other hope but in thee, Queen of Heaven" was not mere words but a part of life. The nation praying before the icon for its salvation put its whole soul into this prayer, confided to the icon all its fears, hopes, sorrows, and joys. And the painters who created the icons were no mere artisans but chosen souls combining the strenuous practice of monkhood with the high joy of spiritual creative art. Andrei Rublev, the foremost icon painter of the later fourteenth and early fifteenth century, was considered a "holy monk" [*prepodobn-yi*] in his lifetime. The chronicles speak of his "great zeal in the observance of fasts and of the monastic way of life." He and his fellow icon painters, "on the holy day of Easter Sunday, seated ... before the divine and revered icons and ceaselessly gazing at them, were filled with divine joy and light, and not only on that day, but also on other days when they did not paint."[1] If we add to this that Andrei Rublev was also renowned as a man of exceptional intelligence and spiritual experience, "surpassing everyone in great wisdom,"[2]

[1]*Chteniia v obshchestve istorii i drevnostei rossiiskikh,* 1847, No. 7, "Smes' " (Miscellanea).

[2]See M. and V. I. Uspenskii, *Zametki o drevne-russkom ikonopisanii,* p. 42.

we shall understand what a priceless historical document the old-Russian icon is. It reflects the *inner* history of Russia's religious as well as national self-awareness and thought, for in those days the history of religious thought was the history of all thought. V. O. Kliuchevskii evaluates as follows the beneficial role of Metropolitan Alexis, Sergius of Radonezh, and Stephen of Perm: "This blessed triad shines like a bright constellation in our 14th century, making it the dawn of the political and moral regeneration of the Russian land."[3] The flowering of Russian icon painting began in the light of that constellation. All our icon painting from beginning to end bears the imprint of the great spiritual feats of Saint Sergius and his contemporaries.

The icon reflects in the first place the general spiritual crisis that shook Russia at the time. *Before* Saint Sergius and the battle of Kulikovo, the Russian spirit was downcast and timorous. Kliuchevskii writes that in those times "in all Russian nerves the impression of horror [of the Tatar yoke] was still achingly vivid." People felt helpless, had lost courage and resiliency. "Mothers frightened unruly children with the bad Tatar; on hearing this evil word, grown-ups panicked and took to their heels."[4]

As we look at the icons of the early and middle fourteenth century, we clearly perceive, next to flashes of national genius, the timorousness of a people unsure of itself, afraid to believe in its own creative powers. At times it seems that the icon painter does not *dare to be Russian.* The faces in the icons are narrow Greek faces, the beards are short, sometimes a little pointed, not Russian. Even the Russian Saints Boris and Gleb at the Alexander III Museum in Petrograd are of the Greek type. Church architecture also is Greek, or of a transitional style between Greek and Russian. The domes are almost round, very slightly pointed: the Russian bulbous dome is barely taking

[3]"Blagodatnyi vospitatel' russkogo narodnogo dukha." V pamiat' prepodobnogo Sergiia. *Troitskii Listok,* No. 9, p. 11.
[4]*Ibid.,* p. 8.

shape. Inside, the churches have upper galleries—again the Greek style, strange to Russian eyes. Typical in this respect is the fourteenth-century Novgorod icon of the Holy Virgin's Protection *[Pokrov]* in the I. S. Ostroukhov collection.

Historical data support this visual impression. The home of Russian religious art in the fourteenth and fifteenth centuries, and the place of its highest achievements, was "the Russian Florence," Great Novgorod. Yet in the fourteenth century the chief representatives of this creative upsurge were men with foreign names: Isaiah the Greek and Theophanes the Greek. The latter was the foremost Novgorod master and teacher of icon painting. Andrei Rublev, the founder of independent Russian painting, was his pupil. These Greeks also worked on churches and cathedrals in Novgorod and Moscow. In 1343 Greek masters decorated the cathedral of the Assumption in Moscow. Theophanes the Greek did the frescos in the church of the Archangel Michael in 1399; and in 1405, together with Andrei Rublev, in the cathedral of the Annunciation. References to Russian icon painters "taught by Greeks" are frequent in fourteenth-century documents.[5] If Russian art had been strong enough to stand alone, there would have been no need for Greek teachers.

We also have more direct evidence of Greek influences on our fourteenth-century icon painters. Saint Sergius's biographer Epiphanius, a well-known monk-priest who had been educated in Greece, asked Theophanes the Greek to make a colored drawing of the Saint Sophia cathedral in Constantinople. Theophanes complied, and a number of Russian painters copied the drawing and used it in their work. In fact, copies of copies passed from hand to hand.[6] This explains the un-Russian, or not quite Russian, architectural style of many churches in fourteenth-century icons,

[5]See M. K. Liubavskii, *Lektsii po drevnei russkoi istorii do kontsa XVI v.* (Moscow, 1916), p. 199.

[6]See Epiphanius's letter to St. Cyril of Belozersk, published by Archimandrite Leonid in *Pravoslavnyi Palestinskii Sbornik* (Saint Petersburg, 1881), Vol. V, Fascicle iii.

especially the *Pokrov* icons, in which the cathedral of Saint Sophia is part of the subject matter.

Now let us turn to fifteenth- and sixteenth-century icons, and we shall see a radical change. Everything in them is Russian—the faces, the church architecture, even the minor details of daily life. This is hardly surprising since the icon painter, like all the rest of Russian society, had lived through a powerful upsurge of *national* feelings. He was filled with the faith in Russia that rings in Pachomius's biography of Saint Sergius. Pachomius writes that the Russian land, after living for centuries without "enlightenment," had finally been blessed with a holy, high enlightenment not granted to other lands, which had adopted Christianity earlier; Russia had attained these exclusive heights thanks to the holy efforts of Saint Sergius.[7] A country capable of giving birth to such luminaries no longer needed foreign teachers of the Faith: according to Pachomius, that country *itself* could *enlighten the world.*[8]

In icon painting the changed mood resulted first of all in the replacement of Greek faces with broad Russian faces, often profusely bearded. That Russian saints, such as Cyril of Belozersk in an icon at the Novgorod Diocese Museum,[9] should have typically Russian faces is only natural, but these Russian traits often appear also in the faces of prophets, apostles, and even the Greek saints Basil the Great and John Chrysostom. Novgorod artists even dare to paint a Russian Christ, as for instance in the "Acheiropoietos Saviour" icon belonging to I. S. Ostroukhov. The architecture of churches depicted in icons changes in the same way. For a striking illustration of this, compare two *Pokrov* icons: the Ostroukhov icon mentioned above [p. 74] and

[7]See *Velikie Chetii Minei* for September 25, Archeographical Commission, p. 1402.

[8]*Ibid.*

[9]A good reproduction can be found in Muratov's study in I. Grabar', *Istoriia russkogo iskusstva,* Fascicle XVIII, p. 45.

Editor's note: P. P. Muratov's chapters on icons in Grabar's *Istoriia russkogo iskussta,* VI, Ch. 1-2, have been translated into French as *Ancienne peinture russe* (Rome and Prague, 1927).

the famous Novgorod icon of the fifteenth century at the Alexander III Museum in Petrograd. The latter, too, depicts the Constantinople cathedral of Saint Sophia (this is clear from the equestrian statue of its builder, the Emperor Justinian, to the left of the church), but in everything else the Greeks' lessons have apparently been forgotten. Nothing remains of the Greek architectural style. Not only the domes but the entire facade has taken on a distinctly flame-like form. There is no doubt that we see a reproduction of typical native art. All the churches in fifteenth-century icons give this *native* impression.

By the end of the fifteenth century, not only the Russian architectural style but Russian daily life has invaded the icon. In an Ostroukhov icon of the prophet Elijah in his chariot, the horses that carry him to heaven against a background of fiery clouds are harnessed in the Russian manner, with a shaft bow. Compare this with the fourteenth-century Elijah icon in S. P. Riabushinskii's collection: there is no shaft bow. The Ostroukhov collection has an icon of Cyril of Belozersk that shows the saint baking bread in a *Russian* oven. Finally, at the Tretiakov Gallery an icon of Saint Nicholas the Miracle Worker includes a Polovets in a *Russian* fur coat.

This introduction of the everyday into the icon denotes no disrespect but, rather, the new mood of a people whose faith in its country has been revived by the deeds of Saint Sergius and Dmitrii Donskoi. From the saint's hermitage had come the ringing appeal to the leader of Russian warriors: "Set upon the heathen boldly, without wavering, and you shall win." Kliuchevskii writes:

> By the example of his life, by his lofty spirit, Saint Sergius raised the fallen spirit of his people, awakened [the people's] confidence in itself, in its strength, and infused it with faith in its own future. He had come from our midst, he was flesh of our flesh and bone of our bone, yet he rose to heights that we did not imagine any one of us could attain.[10]

It is hardly surprising that Russia in her new self-confidence

[10]Kliuchevskii, *Op. cit.*, pp. 23-29. (See footnote 3.)

saw her own image in the sphere of heaven, or that the icon painter, forgetting his Greek masters, began to paint Christs with Russian faces. This was not self-glorification. The time had come for the image of *Holy Russia* to appear in icon painting. During the era of national humiliation and slavery, everything Russian had seemed sickly and worthless, and everything holy had seemed to be foreign, *Greek*. Now great saints had walked the Russian land. Their deeds, by reviving the people's strength, had sanctified and dignified everything in Russia—the Russian church, the Russian face, and even the people's daily life.

Other events of the fifteenth century reinforced this faith in the national genius and at the same time shook the confidence in the old teachers of the Faith, the Greeks. The Union of Florence and the Turkish conquest of Constantinople came just at the time when the domination of the "godless sons of Hagar" over Russia had been definitely broken. The notion of Moscow as "The Third Rome," which evolved under the influence of these events, is too well known to need amplification. Before Moscow, Great Novgorod had begun to call itself "the new Rome," in view of the decline of faith in both of the ancient "Romes." Pious stories were born here, about saints and sacred objects fleeing the defiled centers of ancient piety and moving to Novgorod: the Tikhvin icon of the Virgin miraculously translated from Byzantium, Saint Anthony the Roman with holy relics navigating to Novgorod on a stone. A Novgorod painter turned the latter story into a brilliant apotheosis of the Russian national genius. A picture of this miraculous journey in the Ostroukhov collection is striking not only by its beauty but by the extraordinary strength of national feeling: Above the Roman refugee floating along the Volkhov on his stone, there glow the golden domes of *Russian* Novgorod churches; they are the goal of his journey and *the only worthy place* for the relics entrusted to him by God.

The vision of glorified Russia marks the dividing line between the two epochs of Russian icon painting. This line was drawn by Saint Sergius's spiritual and Dmitrii Donskoi's

martial feats. Before them, the Russian nation knew its
country mainly as a place of torment and humiliation. Saint
Sergius was the first to show it in an aura of divine glory,
and the icon painters brilliantly rendered his revelation,
finding their means of expression not only in churches, not
only in spiritualized human faces, but in the very *landscape*
of Russia. As a setting for divine revelations it may appear
poor and sad, but it is that of a *holy land:* untold riches
are found in the poverty of this "land of the Russian people's
long-suffering patience" [Tiutchev].

A vivid example of this loving religious approach to
the Russian land is the sixteenth-century icon of the Solo-
vetskii saints Zosima and Savvatii in the Ostroukhov col-
lection. With two simple strokes the painter's genius sums
up the outer, *earthly* northern landscape: a double desert—
bare rock and an empty expanse of sea. The artist needs
this poor earthly background to underscore the Solovetskii
monastery's extraordinary spiritual beauty. Nothing mundane
distracts the saints as they pray by the monastery wall—
their attention focuses on the golden domes burning to the
sky. The domes' burst of flame is prepared by the entire
architecture of the churches as its lines rise like waves.
Not only the domes but the walls too end in flame-like
shapes, as is often the case in Russian churches. The whole
design narrows toward the golden crosses in a mighty surge
of prayer. Thus spiritual striving transforms the long-
suffering barren land into joy and beauty. Probably no
other icon renders the *poetry* of the Russian monastery with
equal power.

We must never forget who first revealed this poetry
to the tortured Russian soul. In the sorrowful days of the
Tatar yoke there were few monasteries in Russia, and their
number grew very slowly. According to Kliuchevskii,

> in the hundred years from 1240 to 1340, only about thirty
> new monasteries appeared. But during the next hundred years,
> 1340-1440, when Russia began to rest from external calamities
> and to recover, out of the Kulikovo generation and its im-
> mediate descendants came the founders of up to 150 new
> monasteries.... Until the middle of the 14th century almost
> all monasteries in Russia emerged in cities or near city walls;

> from that time on, the numerical preponderance is definitely on the side of monasteries that arose far from cities, in deep uninhabited woods still awaiting the ax and the plow.[11]

Clearly it stemmed from Saint Sergius, this *love of the native wilderness,* so colorfully recorded in the Lives of Saints and in icons. The beauty of virgin forests, bare rock, empty waters came to be loved as the outer image of another, *spiritual,* aspect of the native land. And side by side with the hermit and the writer, the icon painter celebrated this love.

II

The creative upsurge in our religious art that began in the fourteenth century and reached its peak in the fifteenth was largely determined by the impact of Russia's *great spiritual victory,* whose consequences were countless and immense. It not only changed the Russian's view of his country—it changed his entire spiritual makeup and gave all his feelings a new depth and vigor.

The popular mind acquired an unwonted resiliency, a new ability to resist foreign influences. We know that in the fifteenth century Russia came into closer contact with the West, that attempts were made to convert her to Catholicism, that Italian artists worked in Moscow. Yet Russia did not succumb to these influences nor lose her own identity. On the contrary, it is in the fifteenth century that the religious "Union" collapses and that our icon painting reaches its highest perfection, shaking off foreign tutelage and becoming truly original and Russian.

The same is true of architecture. The fifteenth century was a time of church building in Russia. This too was closely related to the great national successes. Under the Tatar yoke Russia had lost her building skills. The techniques of masonry had been forgotten. When Russians began to build stone churches, their walls collapsed. Russia felt the urge to build when the fear of Tatar raids had been

[11]*Ibid.,* pp. 24-25.

removed. Not surprisingly, the national victory put its mark on the architectural style of the new churches.

This is all the more remarkable since, in view of the Russians' inadequate skills, Italian masters with Aristotele Fioravanti at their head worked on Moscow cathedrals. They taught the Russians to prepare thick, viscous plaster, to bake bricks, and to lay them in the newly perfected manner. But by Ivan III's decree, the architectural design was to follow Russian models. Thus the work resulted in such marvels of purely Russian architecture as the cathedrals of the Assumption and the Annunciation. Not only is there no trace of Italian influences—the bulbous domes attest a liberation from Byzantine influence as well, revealing as they do a totally new, profounder conception of the church. The rounded Byzantine dome represents the dome of heavens covering the Earth. It leaves the impression that the earthly church is complete and therefore does not aspire to anything above it. The church has an immobility that is somewhat presumptuous since it befits only the highest perfection. The Russian church tells a different story—it aspires upward in every line.

Look, for instance, at the Moscow cathedrals of the Assumption and the Annunciation. Their domes, pointed and glowing to the sky like tongues of flame, express a fervor of emotion unknown to Byzantine architecture: they burn with prayer. No foreign suggestions lit these candles to God over Moscow: they express the innermost thoughts and prayers of a people liberated from slavery by God's grace. To sum up, both the architecture and the painting of the fifteenth century reflect the victory of the Russian religious conception.

But the spiritual victory of the national genius is evident not only in the russification of religious art but even more in the enlarged scope of its creative thought.

For Russia the fifteenth century was above all a time of immense joy. Why did it produce the most powerful, gripping images of boundless sorrow?

I have already spoken of the silk-embroidered image of Saint Sergius, a gift from Vasilii Dmitrievich Donskoi.

Compare it with "The Entombment" and "The Deposition" in the Ostroukhov collection, two outstanding examples of fifteenth-century Novgorod icon painting. Don't these icons seem to transport you into the spiritual climate of a "land forsaken by God"?[12] And how is this reconciled with the general joyousness of fifteenth-century religious art? Why is it that the fourteenth century, a time of national distress, has given us no pictures of sorrow equal to these? The answer lies in one of the deepest mysteries of the human soul. A crushed, downcast soul cannot shake off its sorrow and therefore is *unable to express it.* In order to convey spiritual suffering as the fifteenth-century painters conveyed it, it is not enough to experience it, one must *rise above it.* The sorrowful icons of the fifteenth century represent a great victory of the spirit. We can sense in them the prayerful upsurge that in Saint Sergius's time healed the sores of Russia and infused her with courage. Such icons are comprehensible precisely as expressions of the popular mood, the mood of a people just freed from a great trial through heroic faith and self-abnegation. It is clearly felt in the icons that the memory of the recent martyrdom is still fresh. On the other hand, there is in this standing before the cross an absolute certainty of salvation— for salvation has already been granted, it is an accomplished fact.

Here again the icon faithfully reflects the spiritual growth of the Russian people around the turn of the century. Paradoxically, the time of the greatest national successes was also a time of increased asceticism. As has been mentioned, in Saint Sergius's time monasteries began to multiply. Kliuchevskii notes that "the urge to leave the world became stronger not because misfortunes accumulated in it but in proportion to the rise in it of moral strength." The icon with its extraordinarily strong and vivid perception of Christ's Passion also reflects this gradual accumulation of spiritual powers.

However, the main and fundamental trait of the fif-

[12]The collection *Russkaia ikona* (Vol. II) has excellent reproductions.

teenth-century icon is not its sorrow but the joy into which the sorrow is transmuted. The two traits are inseparable: the icon reflects the spiritual state of a people that had died and has risen from the dead. We know that many icon painters, Rublev among them, worked in prayer and tears. And many icons do convey the mood of a mother who has just suffered the pangs of childbirth and is now delirious with joy. This is the joy of Russia's spiritual birth. It is expressed mainly in the unusual richness and brightness of the icon's rainbow colors. No imitations or reproductions can give even an approximate idea of the colors of the fifteenth-century Russian icon. The reason, of course, is that the joy of this heavenly rainbow reflects the beauty and power of a spiritual life unknown to us.

The color combinations are beautiful less in themselves than as expressions of *spiritual meaning*. Let me explain this, using as example the remarkable fifteenth-century icon of the Ascension in S. P. Riabushinskii's collection. At the top of the icon is the sun-like face of Christ ascending in glory. Below is the Virgin, in dark clothing, to stress the contrast with the snow-white angels who separate her on both sides from her earthly environment. The apostles in bright garments form as it were a rainbow around her. This earthly, rainbow refraction of heavenly light conveys more eloquently than any words the meaning of the Gospel's text, "I am with you alway, even unto the end of the world" [Mat. 28:20].

The rainbow appears in many icons, in the most varied combinations, but it always represents the highest joy of earthly and celestial beings. The solar light of the other-worldly sky is refracted through them, or else they are directly introduced into the ambience of divine glory. In the Petrograd *Pokrov* icon the rainbow is composed partly of the saints and apostles surrounding the Virgin and partly of the clouds on which they stand. The icons "In Thee, Dispenser of Blessings, Rejoices Every Creature" show around the Virgin a multicolored garland of angels. In the icons "The Virgin of the Burning Bush" every spirit also has his own color, and all together form a rainbow

around the Virgin and Christ—but only the Virgin and Christ are touched with the royal *gold* of noon sunrays. I have already mentioned [p. 48 of this book] that there was a kind of hierarchy to the colors of Novgorod icon painting, with the white or golden ray in the dominant position. Here I merely want to stress the inner connection between this celestial rainbow and the revelation of supreme spiritual joy that Russia was granted in the late fourteenth century and in the fifteenth. In those days the country experienced the Gospel's glad tidings more vividly than at any other time before or since. In Christ's suffering Russia felt her own recent calvary, and the Resurrection filled her with the joy of a soul just released from hell. At the same time, the generation of saints that lived in Russia and healed her wounds made her constantly feel the active power of Christ's promise, "I am with you alway, even unto the end of the world." The feeling that Christ's power was effectively participating in the life of mankind and the life of the Russian people finds expression in all Russian art of the time—in the architectural lines of the churches and the colors of the icons.

III

To understand the great period of Russian icon painting, one must think through, and especially *feel through,* the movements of soul and spirit that the icons answered. The story is most clearly and colorfully told in contemporary "Lives" of saints.

What did Saint Sergius see and feel as he prayed for Russia in his woodland wilderness? Around him, near by, stands "the devil's watch," and animals howl. From afar, from the places where people live, come the moans and laments of the land dominated by Tatars. People, animals, devils combine to form a chaotic likeness of hell. The animals roam in herds, sometimes in twos or threes that come close and sniff at the saint. People behave like devils, and the devils described in the Lives horribly resemble people. They appear to the saint in disorderly congeries, a "countless

herd," shouting in a medley of voices: "Go, go away from here! What seek you in this wilderness? Don't you fear to be killed by hunger, or by the beasts, or brigands and murderers?" But prayer chases away the devils. Prayer subdues chaos, vanquishes hate, and restores the peace between man and animals that existed on earth before the fall. One animal, a bear, took to visiting the saint regularly. Seeing that he meant no harm and came mainly for food, Saint Sergius would put out some bread on a tree stump or a log. When there wasn't enough food, both went hungry. Sometimes the saint would give the bear his last chunk of bread "so as not to offend the beast." Relating how the animals obeyed Saint Sergius, his disciple Epiphanius remarks:

> Let no one wonder at this, knowing for certain that when God and the Holy Ghost inhabit a man, everything obeys him as it did the first-created Adam before God's law was transgressed, when he too lived alone in the wilderness and all obeyed him.

This page in the Life of Saint Sergius and many similar pages in the Lives of other saints provide the key to the highest inspirations of fifteenth-century icon painting.

Universal peace, mankind gathered around Christ and the Virgin, the lower creatures gathered around man, in the hope of restoring the lost order and harmony—that was the innermost thought of Russian hermits and Russian icon painters, the thought they opposed to the howling of beasts, the devil's watch, and bestial humanity. This thought, inherited from the past, from the centuries-old religious tradition, appears in Russian monuments as early as the thirteenth century, but it has never been expressed more beautifully and profoundly than in fifteenth-century icon painting.

That one and the same religious idea inspired both the hermits and the icon painters of the time is especially clear from the icon behind the altar of the Trinity cathedral at the Troitsko-Sergiev monastery. It is an icon of the Old Testament Trinity painted in or about 1408 by Andrei Rublev in honor of Saint Sergius, only seventeen years after the saint's death, on the order of his disciple, the saintly

monk Nikon.[13] It expresses the fundamental idea of Saint
Sergius's activity. What do they tell us, these three angels
with their gracefully inclined heads, their hands blessing
the world, their eyes looking with love at something that
lies below? Why is their downward gaze so full of deep,
noble sadness? We come to realize that they represent the
words of Christ's first pontifical prayer, in which the
thought of the Holy Trinity mingles with sadness for the
people languishing *below:* "And now I am no more in the
world, but these are in the world, and I come to thee. Holy
Father, keep through thine own name those whom thou
hast given me, that they may be one, as we are" [John
17:11]. This thought inspired Saint Sergius when he erected
the cathedral of the Trinity in the dense woods, to the
howling of wolves. He prayed that the bestial world divided
by hate be filled with the love that presided at the council
of the original Trinity. His prayer expressed both his sorrow
and his hope for the Russian land. Andrei Rublev rendered
it in paint.

A call to victory rang in that prayer. It instilled courage
into the Russian people and made it look upon the native
land as "sacred ground." Everything we know of Andrei
Rublev suggests that he was inspired by the victory that
vanquished the world. This impression is especially strong
in his admirable fresco of the Last Judgment at the cathe-
dral of the Assumption in Vladimir-on-the-Kliazma. Victory
is proclaimed by the powerful figures of angels imperiously
trumpeting upward and downward to call the celestial and
the earthly creatures to the Almighty's throne. Angels, men,
animals stream forward in response to the call. The righ-
teous proceeding to paradise gaze intently ahead, and we
sense their unflagging purpose and their joy at the close-
ness of the goal.

Everything in this fresco is characteristic of the era of
great spiritual upswing—the majestic images of spiritual
power, and the broadly ranging thought. Fifteenth-century

[13]There is a good reproduction in Muratov's chapter in I. Grabar'.
Istoriia russkogo iskusstva, Fasc. XX.

icon painting is astonishingly rich in conceptions of world-wide scope. And all of them are variations on one and the same theme—paeans to the power that will overcome universal discord and change chaos into cosmos. Significantly, the two best images of Sophia the Divine Wisdom, unequalled anywhere in the world, also date from the fifteenth century. One is at the Alexander III Museum in Petrograd; the other, embroidered in silk, was given by Count Olsufiev to the Moscow Historical Museum.

The thought expressed in these icons was not new: our forefathers took it from the Greeks as soon as they were baptized, when churches dedicated to Saint Sophia were springing up all over Russia. The oldest "Sophia" icon, above the main altar of the Novgorod church of Saint Sophia, dates from the eleventh century. Yet the feeling in the fifteenth-century icons is strikingly fresh.

Note how much profound thought has gone into this image.[14] Sophia is God's design that preceded the beginning of time, the Wisdom that created the world. Therefore it is natural to associate Sophia with the original Word—and this is done in the icon. In its upper part we see an image of the Word: the New Testament surrounded by angels. This illustrates the opening words of John 1:1, "In the beginning was the Word." Lower, the Word appears in another guise—the figure of Christ in the solar radiance of divine glory, Christ the Creator, according to the third verse, "All things were made by him; and without him not any thing made that was made." Still lower, directly under the figure of Christ, there is Sophia the Divine Wisdom against a dark starry sky. What does the darkness of night signify? It illustrates another verse of the Gospel, "And the light shineth in darkness, and the darkness comprehended it not." The shining stars in that sky represent the lights lit in the darkness by Sophia the Divine Wisdom, the sparks of divine light she has scattered throughout the dark; they are the worlds brought forth from the night of non-being by her creative act. As we look at this starry

[14]Reproduced in the first issue of the journal *Sophia.*

night around Sophia, a line from *Golubinaia kniga* [Book of the Dove] comes to mind: "Dark nights come from God's thoughts." Elsewhere I have explained (pp. 51-54 of this book) why Sophia's face, hands, and wings are painted red. The red represents God's dawn amid the dark of non-being, the eternal sun rising over all creatures. Sophia is what precedes the *days* of creation, the power that summons the day out of the darkness of night. What color could have been more suitable for Sophia than the red of dawn?[15] Two other figures in the icon also remind the onlooker of the Gospel story's beginning—the Virgin and John the Baptist, witnesses for the Word.

I repeat, there are earlier and later images of Sophia, but none attain the perfection of the fifteenth-century icons. Look, for instance, at the seventeenth-century Sophia on the pediment of the cathedral of the Assumption in Moscow: the stars shine in a light blue sky, and the symbolism of the starry night is lost. In other icons, the red is lost. The deep dark of night and the beauty of God's dawn, clearly seen by the fifteenth-century Novgorod painter, are hidden from his successors. This is hardly surprising: At the end of the fourteenth century and the beginning of the fifteenth, Russia saw the dawn of a great creative day; the victory of the Spirit over the darkness was made manifest. In order to feel so strongly the beauty of God's design, one had to live during that era of surging creative power.

There is another reason why the thought of "Sophia" was close to fifteenth-century Russians: it is linked with the idea of the *unity of all creation.* Discord may reign in the world, but there is no discord in the plan of the Divine Wisdom that has created the world. In that Wisdom, *all are at one*—angels, men, beasts. This thought of peace among all creation is already vividly evident in twelfth-century

[15]According to an old Byzantine legend, the red of Sophia's face appeared in a vision to the son of the architect who was then building the Saint Sophia cathedral in Constantinople. (See Filimonov's article in *Vestnik drevne-russkogo iskusstva,* 1874, pp. 1-3.) But the setting of the vision (the night sky, and so on) is due to the icon painter's own creative imagination.

monuments, at the cathedral of Saint Demetrius in Vladimir. The remarkable ornaments on its outer wall show animals and birds gathered amid fantastic flowers around the spokesman for the Divine Wisdom, King Solomon. These are not the animals we see on earth but beautiful idealized creatures envisioned by God and gathered in a blooming paradise by the creative act of the Divine Wisdom.

In the generation that grew up under the beneficent influence of Saint Sergius, the thought of restoring the Edenic relations between man and beast was very strong. Little wonder, therefore, that it was a favorite theme of fifteenth-century Novgorod painters. Many icons illustrate the prayer, "Let all breathing things praise the Lord": we see *all* creatures gathered around Christ. Thus, in N. V. Khanenko's collection in Petrograd there is a Novgorod icon depicting Christ in an aura of celestial spheres with angels floating in them, while people and animals gather below, on earth, amid plants of paradise. Many other icons I have described (pp. 29-33 of this book) also deal with the theme of restoring through love the unity of a divided world—a joyous affirmation of victory over chaos.

One facet of this thought is particularly stressed in fifteenth-century icons. We know that this was a time of intensive church building, in both the spiritual and the literal sense. The monastic ideal spread and deepened, and monastic communities multiplied in formerly uninhabited places. Church building soared to new heights: freed of the fear of Tatar raids, Russia built a great many churches. The icons naturally reflected this activity.

Images of churches, always in a purely Russian architectural style, are extremely common in fifteenth-century icons. More impressive than their number, however, is the ideological meaning of these churches. In another essay [p. 19 of this book] I said that the church was seen as an all-embracing *sobor*. Take a look at, for instance, the "Protection" *[Pokrov]* icons of the fifteenth century and compare them with those of the fourteenth. In a fourteenth-century icon the "holy fool" Saint Andrew has a vision of the Virgin. She appears to him above a church—and that is all.

Now look attentively at a fifteenth-century *Pokrov:* the vision has acquired *universal meaning.* Time and place are forgotten; you feel that *all mankind* is gathered under the Virgin's Protection. The same is true of the icons "In Thee Rejoices Every Creature," much in demand in the fifteenth century: "the heavenly host and human kind" both appear in them, gathered in the church around the Mother of God. The Siisk monastery has a later icon, in which the same church is surrounded by animals and birds, making it truly a *sobor* of all creatures, earthly and celestial. This thought was passed on to a later era of icon painting, but we must not forget that the fifteenth century gave it the most beautiful, and most Russian, expression. When we see that the church in which all the celestial and earthly creatures are gathered is topped by a Russian dome, we find ourselves, as it were, in the spiritual climate of the era that brought forth the dream of "The Third Rome." With the Greeks' deviation into union with the Papacy and the fall of Constantinople, Russia became for our forebears the only defender of pure Orthodox faith. Hence the belief in her universal significance—and the tendency to identify the Russian with the universal, which can be felt in the icons.

What is most valuable, however, in this ideology of Russian icon painting is not the enhanced national self-awareness it reflects but the depths of mysticism it opens to us. The icon painter sees the future world as a temple of God, a *sobor.* This denotes a remarkably profound understanding of the principle of communality. Here on earth communality is realized only among people, but in the future world it becomes the underlying principle of world order as a whole, extended to include "all breathing things," all the "new creatures" to be resurrected in Christ together with man.

In general, the visions of the fifteenth-century icon painters are artistic embodiments of the rich religious experiences opened to Russia by a generation of saints, beginning with Saint Sergius of Radonezh. Because his strong spiritual influence is unquestionably manifest in the works of Andrei Rublev and others, some historians speak of a

distinct "Saint Sergius school of icon painting." This is of course an "optical illusion"—no such school existed. However, as the proverb says, where there's smoke there's fire. Without having founded a new school of painting, Saint Sergius nevertheless exerted an enormous indirect influence on icon painting, as the originator of the spiritual ambience in which the best men of the fourteenth and fifteenth centuries lived. The turning point in Russia's spiritual life that we associate with his name was also a turning point in the history of our religious painting. Before Saint Sergius, it had been by and large a Greek art, despite occasional flashes of Russian genius. It became independent and national after the appearance of Saint Sergius, the foremost figure in a long line of great Russian ascetics.

Our artists expressed in painting the great spiritual revelations that the country received at the time. It is hardly surprising if we find in their work an unusual depth of creative insight, both esthetic and religious.

In the beautiful images of their inspired visions an attentive eye discerns a remarkably complete and harmonious system of beliefs about God, the world, and especially the church in its truly universal, that is to say, not merely human but cosmic meaning. Icon painting belongs in the first place in the church: an icon is incomprehensible outside the *sobornoe* [communal] whole of which it is a part. The principal idea of a Russian Orthodox church is this: The church is more than a house of prayer, it is a *complete world.* Not the sinful, chaotic, divided world we know but a world united by grace, mystically transmuted into the body of Christ. As we have seen, the outside of the church represents an upward thrust, a prayer lifting a mass of stone to the cross, with tongues of flame descending upon it from heaven. Inside, the church is the place where the greatest of all sacraments is consummated, the one that initiates the gathering of all creatures. Truly the whole world gathers in Christ through the sacrament of the Eucharist: the heavenly host, and earthly humanity, both living and dead; and in the Eucharist also lies the hope of the lower creatures, for, as the apostle says, "the earnest expectation of the

creature waiteth for the manifestation of the sons of God"
and for its final deliverance from bondage and corruption
(Rom. 8:19-22).

The structure itself of our churches, and all our icon
painting, represent the Eucharistic understanding of the
world as the future body of Christ—a world that in the
future life is to become identified with the church. This
is the basic idea of all our church architecture and icon
painting, but these arts reached their highest eloquence in
the fifteenth century, and partly in the sixteenth, which
retained something of the thrust of the great creative era.

With an authority unknown to the art of our time, these
churches express the meeting of the divine and the human
that draws the world together and makes it a house of God.
Above, in the dome, Christ blesses the world from a dark
blue sky; below, everything aspires upward, to the one
spiritual center—Christ extending the Eucharist.

Take any iconostasis of the classical era of Novgorod
icon painting,[16] and you will notice a detail that sharply
distinguishes old Orthodox churches from modern ones:
there is no representation of the Last Supper over the royal
gates. The custom of painting the Last Supper above royal
gates is a fairly recent and not very happy innovation. In
old churches it is a picture of the Eucharist that appears
above the royal gates and sometimes in the upper part of
the gates themselves. At the center of these icons, two
images of Christ are painted: he is handing the apostles
bread on one side, and the holy chalice on the other.

Obviously the old way expressed the central idea of the
Orthodox church much more clearly and profoundly, since
the most important thing is the miraculous transmutation
of the faithful into Christ's body. Hence the central place
above the royal gates by right belongs to the Eucharist and
not to the Last Supper, which includes much else besides
a partaking of Christ's flesh and blood. It includes the
Saviour's last conversation with his disciples, and his words

[16]For instance, the one in the chapel of the Virgin's Nativity at the
Novgorod cathedral of Saint Sophia (16th century).

to Judas. Important as these are, they are not the main point. We gather in a church not just to converse with Christ but to unite mystically with him in our entire beings.

The old iconostases surpass the modern as works of art as well. Their overall artistic conception is more unified: everything in them points to the living center much more clearly. What do the evangelists write about? What does the archangel announce to Mary? The theme is always the mystical, miraculous conjunction of the divine with the human, granted through the Eucharist to all of humanity. Look how powerfully the Novgorod hierarchy expresses the universal aspiration toward Christ! What do we learn from the figures of the Virgin, John the Baptist, the archangels, apostles, and hierarchs bowing to Christ on both sides? They represent the *sobor* of angels and men gathered around Christ. But without the Eucharist this gathering does not attain the *goal* of its aspirations, for the ultimate, highest goal is not the adoration of Christ but indivisible, though non-merging, union with him. Look at the incomparable Novgorod gates in the Ostroukhov collection and you will understand what makes the ancient Novgorod churches so majestic and beautiful: in these gates the entire spectrum of colors and all the joy of angels and men focus on the Annunciation and the Eucharist—the glad tidings of spring and the sacrament of eternal life. I know of no more beautiful expression of this mystical conception of the church, which is what mainly distinguishes the Orthodox from the Catholic faith. For Catholics, the unity of the church is personified by its earthly head, the Pope, whereas for the Orthodox it is not given in any visible earthly form but in the sacrament of the Eucharist. The church unites all the faithful not in an outward union but through the mystical communion of their life in Christ. All the beauty of old-Russian icon painting is but the translucent shell of this mystery, its rainbow-hued cover. And the beauty of the cover comes from the extraordinarily deep insight into the mystery, which was possible only in the era of the greatest Russian saints.

IV

The foregoing analysis of the meaning and significance of fourteenth and fifteenth-century Russian icon painting also explains its strange and mysterious fate. Breathtakingly beautiful religious painting existed in Russia more than five centuries ago, and yet it is a discovery of modern times. Until recently the ancient icon was not merely incomprehensible—it was invisible. Because our forefathers did not know how to clean paintings, an icon blackened by incense and candle smoke was simply "done over," that is, new paint was applied to the old design; occasionally the design itself was slightly changed. Sometimes the icon was discarded as trash. The usual place for discarded icons was the belfry, where they were exposed to the weather and often to pigeons. A good many marvels of old-Russian art have been found in belfries in horrifying piles of filth and trash. Only some fifteen years ago did our artists begin to "clean" icons, that is, to remove the layers of deposits and repaintings.

Recently at I. S. Ostroukhov's I was present at a "cleaning." The artist who did the work showed me a flat board, coal-black, as if charred in a fire, and asked me what I saw on it. I was nonplussed: try as I might, I could see no trace of any design. To my astonishment, he said that the icon depicted Christ sitting on a throne. As I watched, he poured a little alcohol and oil over the place where Christ's face was supposed to be, and lit the mixture. When the film had softened, he extinguished the flame and began to scrape the spot with a penknife. Soon the Saviour's face appeared: the old paint looked fresh and new. "Overpaintings" are removed with equal success. Rublev's icon of the Trinity, which I have described earlier, was restored thanks to the efforts of I. S. Ostroukhov and the painter V. P. Gurianov. The latter "had to remove from the icon several successive layers of overpainting to reach the original ancient painting, which luckily turned out to be fairly well

preserved."[17] After the cleaning, the icon was unfortunately put back into its gold setting, with only the faces and hands left visible. Only thanks to photographs do we have any idea of what the whole icon looked like.

The beautiful works of our old icon painters suffered one or other of two strange fates: either they turned coal-black or they were almost covered with gold. The result in both cases was the same: the icon became invisible. Both extremes—the neglect and the senseless cult—attest that we had ceased to understand the icon and therefore had lost it. It was not merely a matter of misunderstood art. The great revelations of the past were forgotten because of our profound spiritual decline. We must ask ourselves how and why this happened.

In the great period of icon painting, the icon was a beautiful image of deep religious thought and deep religious feeling. A fifteenth-century icon reminds us of Dostoevsky's immortal words, "Beauty will save the world." Our fifteenth-century forebears sought nothing in the icon but the beauty of God's design that would save the world. Therefore the icon was indeed the expression of a great creative design. This was true in the days when prayer was the source of inspiration, and the spirit of Saint Sergius dwelt in the creations of the Russian national genius. This high spirituality lasted for about a century and a half. The temporal successes gained by Russia during that time held the seeds of dangerous temptations. In the sixteenth century the religious mood began to fade. People began to approach the icon with different feelings and demands.

Side by side with works of genius, there appeared more and more icons that betray a loss of religious fervor. In the new atmosphere of prosperity the icon gradually became an object of luxury serving extraneous purposes. As a result, a great art lost much of its creative power and began to deteriorate. The fifteenth-century icon painter concentrated exclusively on a grand religious and esthetic design.

[17]See Muratov's study of the Rublev era in Grabar's *Istoriia russkogo iskusstva*, XX, 228. (See fn. 9.)

In the sixteenth century other considerations apparently came into play. Secondary details, ornamentation, the saints' beautiful garments, the Saviour's richly decorated throne began to interest the painter for their own sake, apart from the spiritual content of forms and colors. This kind of painting was subtle and delicate, often highly skilled, but on the whole shallow, lacking both intense feeling and lofty spirituality. It was craftsmanship rather than creative art. Most icons of the so-called Moscow and Stroganov schools give this impression.

From there it was only a step to the gold settings. Once the icon had come to be prized as a showpiece rather than a revelation of religious experience, why not dress it in gold, why not make it literally a product of the goldsmith's or jeweler's art? What resulted was worse than a black charred board: Blessed wonders of art, born in tears and prayer, were hidden behind rich settings [*rizas*], an invention of pious bad taste. The custom of encasing icons, which appeared late, probably not before the seventeenth century, in fact implied a covert rejection of religious painting. Fundamentally, it was unconscious iconoclasm. Hence the "loss" of the icon of which I have spoken: its meaning was totally forgotten.

If we give some thought to the reasons behind this loss, we shall see that the fate of the icon parallels the fate of the Russian church. One might say that the history of the icon illustrates the history of Russia's religious life. The flowering of icon painting reflected the high spirituality of the generation that matured under the influence of the great Russian saints; later, the decline in icon painting reflected the impoverishment of religious life. Icon painting was a great art while Russia was being built by the beneficent power that resided in the church; in those days the secular order, too, was strong with that power. Afterward, things changed. The corrupting influence of mundane grandeur affected the church, enslaving it and gradually turning it into a subordinate instrument of the temporal powers. The royal splendor, in which it had a part, eclipsed the life-giving revelations of the church, and

its role as sovereign eclipsed its role as community, as *sobor*. Its image faded in our religious consciousness and lost its ancient colors. The icon's darkened face in a rich golden setting is the very image of the church as prisoner of earthly magnificence.

There is something almost miraculous in the icon's history. It is miraculous, for instance, that the icon suffered so many reverses and yet remained virtually intact. It was assailed by a host of enemies: indifference, neglect, lack of understanding, a tasteless, imperceptive cult. But even this mighty coalition failed to destroy it. The film of smoke, and the overpaintings, and the gold often served as a kind of box that protected the icon's ancient design and colors. It is as if throughout the bad years an invisible hand preserved the icon for a later generation, which would again be able to understand it. The icon has suddenly appeared to us in all its beauty, almost untouched by time. This alone is like a newly manifested miracle.

Surely it is no accident that the icon has come to us during the past ten or fifteen years, that it was discovered just before we were going to need its closeness and would again understand its forgotten language. The icon appeared on the eve of the historic events that would bring us close to it and renew our feeling for it.

The spiritual upsurge that the icon originally reflected was born of the Russian people's greatest sufferings. Now another period of suffering is upon us. Again, as in the days of Saint Sergius, Russia faces the question, To be or not to be. Is it any wonder if over the distance of centuries we again hear the prayers of Russia's holy protectors and understand the tears of Andrei Rublev and his followers?

At first glance, the present historical setting seems to have little in common with the past. Saint Sergius's wilderness is densely populated. No beasts, no devils roam in it. But look attentively at your surroundings, and listen. Don't you see devils at every turn, hear the howling of wolves on all sides? In our time, men have become wolves. As in the past, herds of wild beasts roam the earth, enter peaceable hamlets and holy retreats, sniffing around for

tasty food. Are we better off because today's wolves are bipeds? Everywhere pillage and murder cry to heaven, and we can still see "the devil's watch." Saint Sergius's devils astonishingly resembled humans; today many humans frighteningly resemble devils, and they speak to the holy men praying in our monasteries much as they did to the older saint. The same "countless herd" shouts in a medley of voices, "Go away, leave this place. What seek you in this wilderness? Don't you fear to be killed by hunger, or by the beasts, or brigands and murderers?" To be sure, the tempters look somewhat different. Saint Sergius saw them in pointed Lithuanian caps, as devils were painted in icons at the time. Today they are differently attired, but the difference is only in the attire, not in their essence. "The devil's watch" is the same as of old, and "the abomination of desolation which stands where it should not" is no better but much worse than in Saint Sergius's time. Amid the horrors of enemy invasion, just as it did under the Tatar yoke, rises the desperate cry, "Save us, our country is going under."

We have learned to understand the spiritual life of the generations whose suffering brought forth the icon, five hundred years ago. *The icon is a manifestation of the beneficent power that once saved Russia.* Amid ruin and danger, Saint Sergius gathered Russia around the cathedral of the Holy Trinity he had built in the wilderness. In homage to the saint, Andrei Rublev painted in fiery brushstrokes an icon of the Triune around which the universe must gather and unite. Since then this image has always been the banner under which Russia rallies in times of great stress. The reason is clear: The only recourse from the troubles that dismember a nation and threaten its life is the power that resounds in the call of the prayer "That they be one as we are."

This call resounds in all fifteenth-century icons, not only in Rublev's. They also contain something that fills the soul with boundless joy: the image of Russia renewed, resurrected, and glorified. Everything in these icons speaks

of the people's hope, of the spiritual effort that gave Russia back to her people.

The same hope sustains us now. It finds support in the present remarkable events. Again the fate of the ancient icon coincides with that of the Russian church. In life as in painting, the same thing happens: the darkened face is freed from age-old layers of gold, smoke, and tasteless, unskilled overpaintings. The image of the world-embracing church that shines for us in the cleaned icon is miraculously revived in the real life of the church. In life as in painting, we see the undamaged, untouched image of the church-*sobor*.

And we firmly believe that now as before this holy unity will be the salvation of Russia.

1917

Appendix

By George M. A. Hanfmann

1. MUSEUMS AND COLLECTIONS

Trubetskoi's essays were written before the Russian Revolution of 1918. Since then, private collections have been abolished, museums reorganized and renamed, and a special program of scientific conservation of icons has been instituted. Many churches mentioned by Trubetskoi have become museums and historical monuments.

Major collections used by Trubetskoi have changed their names. The Museum of Alexander III, St. Petersburg, is now The State Russian Museum (*Gosudarstvennyi Russkii Muzei*), Leningrad. I. S. Ostroukhov's Collection, Moscow, was catalogued as private collection by P. P. Muratov, *Drevnerusskaia ikonopis v sobranii I. S. Ostroukhova* (Moscow, 1914). Some of the important icons but not the entire collection are now in the Tretiakov Gallery. The icons are listed by Antonova and Mneva (see below).

P. M. Tretiakov's Collection, Moscow, city-owned since 1892 is now The Tretiakov State Gallery (*Gosudarstvennaia Tretiakovskaia Gallereia*). Many of the icons discussed by Trubetskoi are described in the monumental catalogue of the Tretiakov Gallery by V. I. Antonova and N. E. Mneva, *Katalog drevnerusskoi zhivopisi XI - nachala XVIII veka* (Moscow, 1963, 2 volumes). The catalogue is preceded by an introduction which details the history of icon collecting and research on icons. It contains descriptions of over one thousand icons and paintings with detailed bibliographies in Russian and other languages.

2. BIBLIOGRAPHY

Bernard Meares, translator, *Around the Kremlin*. The Moscow Kremlin, Its Monuments and Works of Art (Moscow, Progress Publications, 1967). Describes the present situation of historic churches.

Igor E. Grabar, *Istoriia russkogo iskusstva,* 1st ed. (1909), used by T. German translation, *Geschichte der russischen Kunst* (Dresden, 1957).

George H. Hamilton, *The Art and Architecture of Russia* (The Pelican History of Art, Baltimore, 1954). Excellent survey; discusses and illustrates many buildings and icons cited by T. Good bibliography.

A. Vyse, *The Art and Architecture of Medieval Russia* (University of Oklahoma Press, Norman, Oklahoma, 1967), with useful glossary of Russian terms.

Michael S. Farbman, editor, *Masterpieces of Russian Painting.* Text by A. I. Anisimov, M. Conway, R. Fry, I. Grabar. Exhibition of Icons Circulated by Central State Restoration Workshops, Moscow. (Europa Publications, London, 1930). 60 pls., some in color.

M. P. Kondakov, *The Russian Icon* (translated by E. H. Minns, Clarendon Press, Oxford, 1927). Summation of Kondakov's monumental four volume study in Russian. Strong on iconography. Illustrations are principally of icons in State Russian Museum, Leningrad.

V. N. Lazarev, *Novgorodian Icon Painting.* Parallel English and Russian texts, many color illustrations (Edition Iskusstvo, Moscow, 1969).

Konrad Onasch, *Icons* (A. S. Barnes, South Brunswick, 2nd American Edition, 1969). 151 color plates of icons in Russia, with careful descriptions and bibliographies.

Leonid Ouspenski and Vladimir Lossky, *The Meaning of Icons* (Boston Book and Art Shop, 1952). An important work on the theological and iconographic aspects of the Russian icons with detailed explanations of subject of some 200 icons arranged according to their themes. Illustrations are drawn almost entirely from private collections outside Russia.

G. P. Fedotov, *The Russian Religious Mind,* Volume II, ed. with a Foreword, by John Meyendorff (Harvard University Press, Cambridge, Mass., 1966).

George Vernadsky and Michael Karpovich, *A History of Russia,* Volumes I-IV (New Haven, 1943-1959), especially Volume III, *The Mongols and Russia* (1953).

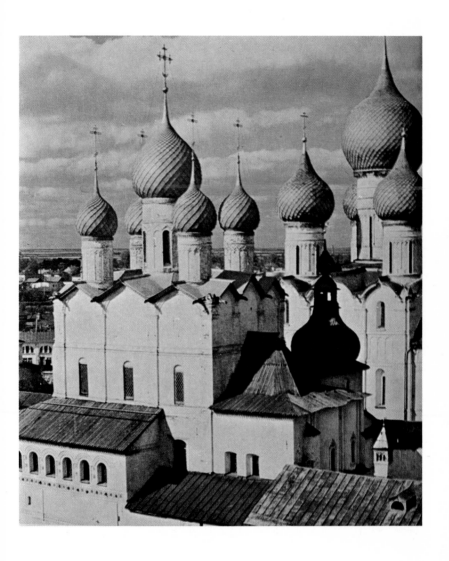

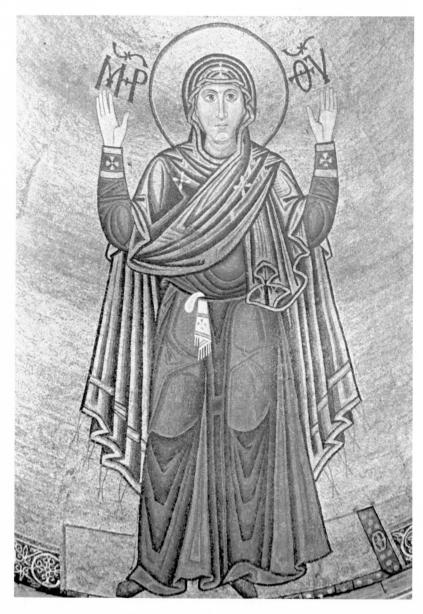

THE VIRGIN - KIEV - ST. SOPHIA
Mosaic in the apse. XIth c.

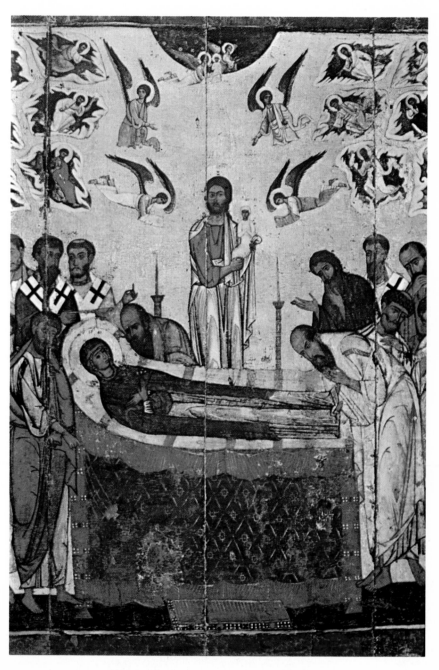

THE DORMITION - NOVGOROD SCHOOL
Early XIIIth c. Moscow, Tretyakov Gallery.

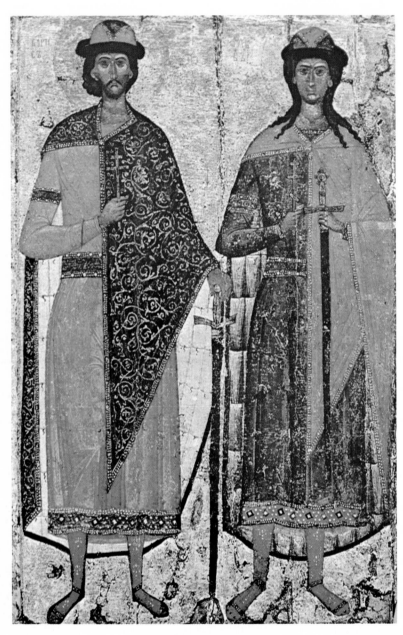

STS. BORIS AND GLEB
Early XIVth c. Russian Museum, Leningrad.

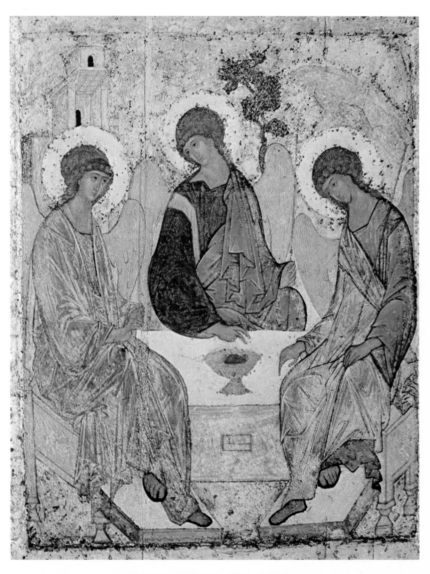

ANDREI RUBLEV - THE TRINITY
Moscow, Tretyakov Gallery, Circa 1411.

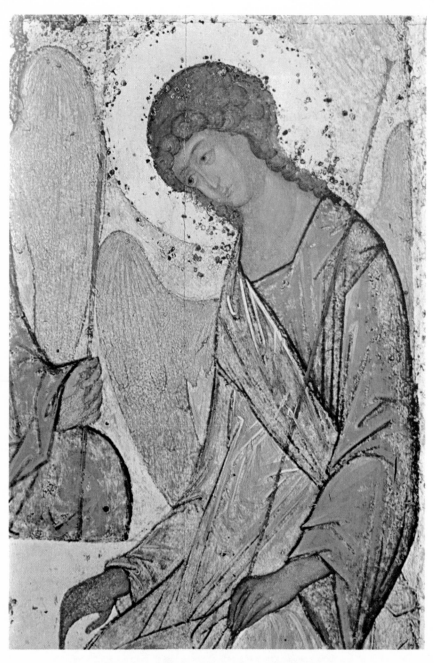

ANDREI RUBLEV - THE TRINITY
Detail: The Angel on the left.
Moscow, Tretyakov Gallery, Circa 1411

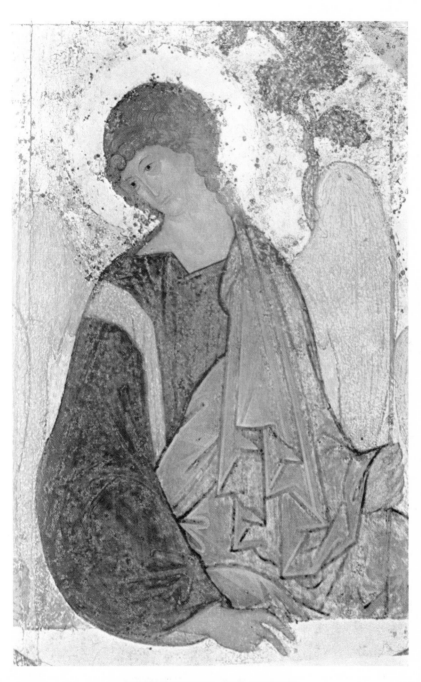

ANDREI RUBLEV - THE TRINITY
Detail: The Angel in the center.
Moscow, Tretyakov Gallery, Circa 1411

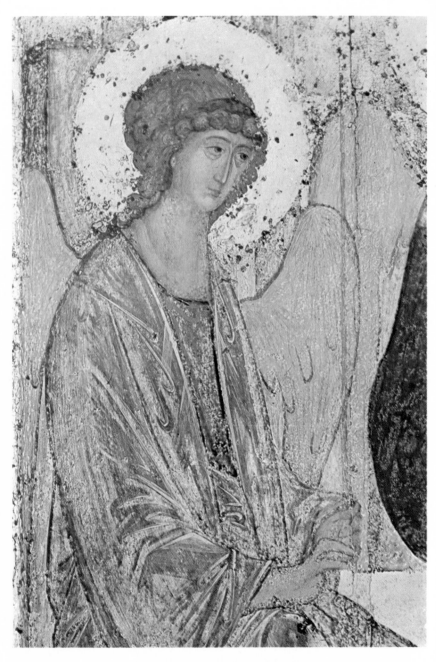

ANDREI RUBLEV - THE TRINITY
Detail: The Angel on the right.
Moscow, Tretyakov Gallery, Circa 1411

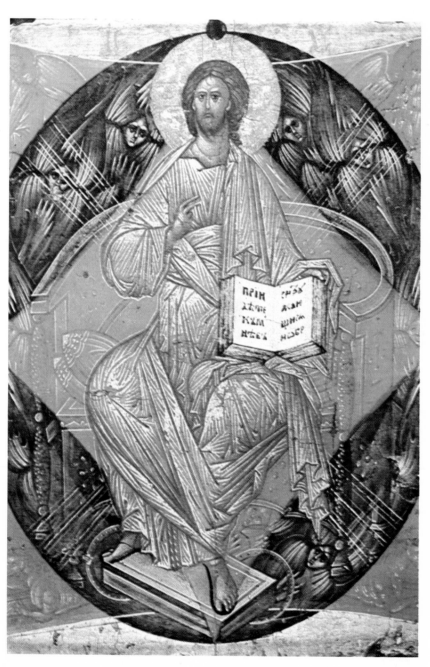

ANDREI RUBLEV - CHRIST IN GLORY
Tretyakov Gallery, 1410-1415.

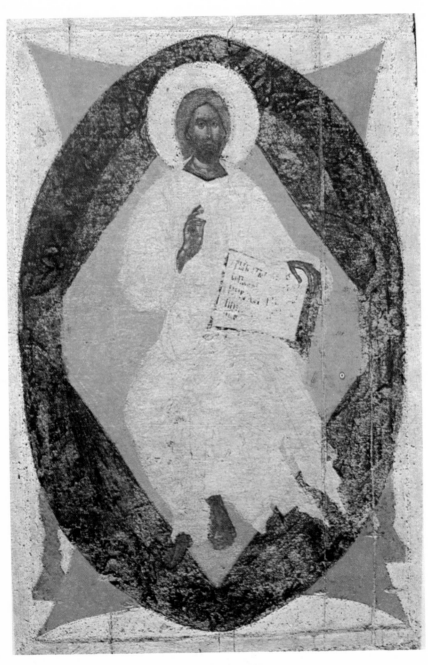

THEOPHAN THE GREEK CHRIST IN GLORY
Iconostasis - Annunciation Cathedral, Moscow, 1405

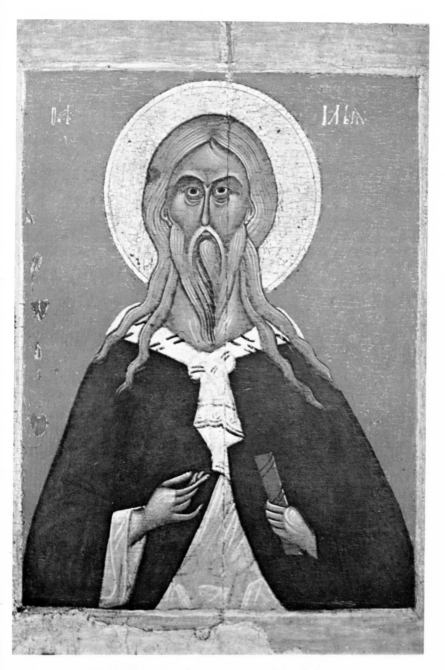

ELIJAH THE PROPHET - SCHOOL OF NOVGOROD
XIVth—XVth cc., Moscow, Tretyakov Gallery.

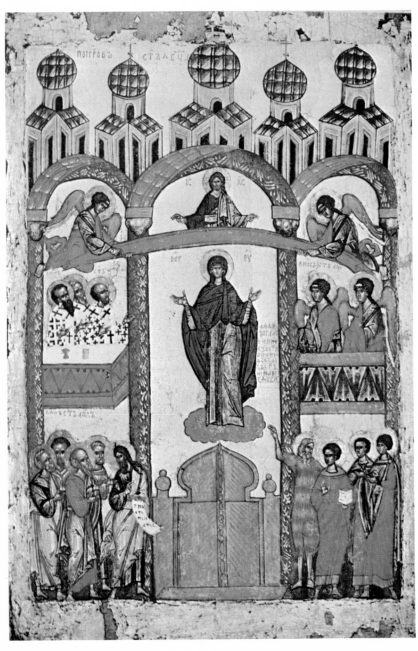

THE VIRGIN'S PROTECTION (POKROV),
SCHOOL OF NOVGOROD
XVth c., Moscow, Tretyakov Gallery.

ST. SERGIUS - EMBROIDERY
XVth c. Zagorsk.

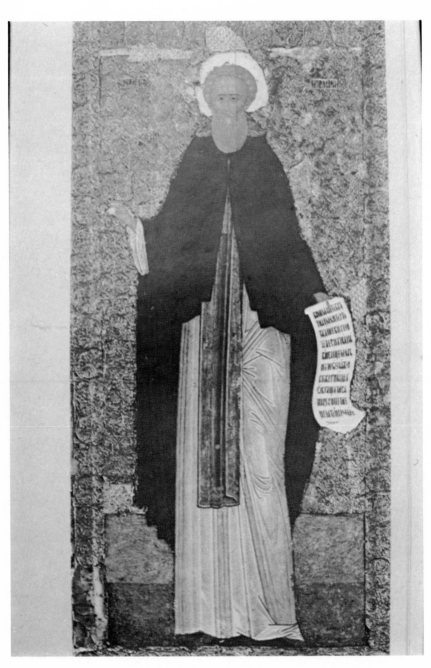

ST. CYRIL OF BEBOOZERO
Early XVIth c. Russian Museum, Leningrad.

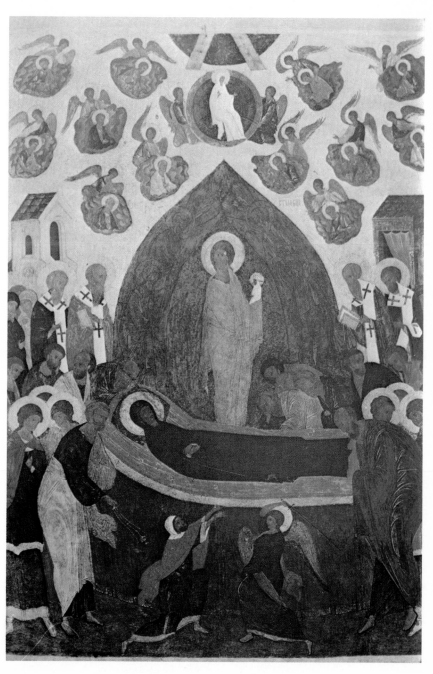

DORMITION - WORKSHOP OF DIONISY
Moscow: The Rublev Museum of Old Russian Art XVIth c.

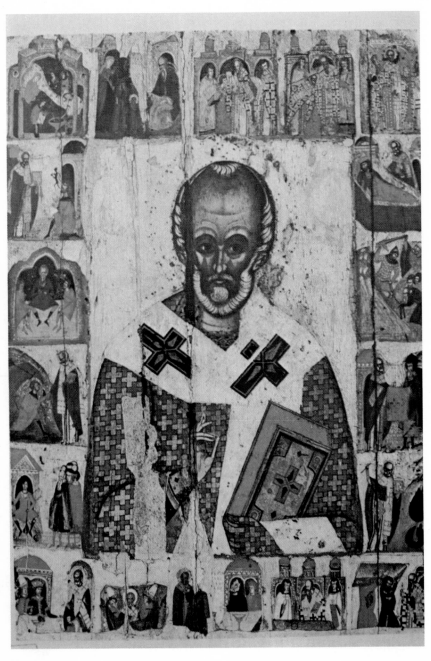

ST. NICHOLAS AND HIS LIFE
Middle of the XIVth c. Moscow, Tretyakov Gallery.